IMAGES
of America

CORTLAND COUNTY

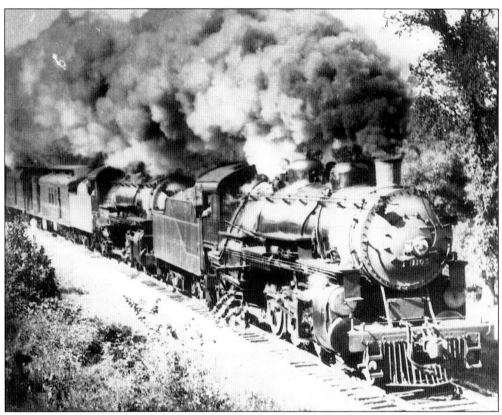

Emblematic of the role transportation continues to play in the life of Cortland County is the Delaware, Lackawanna, and Western's No. 1105, double-heading into the city from the south. The name of the line may change, but the route is still available for freight and passengers. In the heart of New York State, from Joseph Chaplin's State Road of the 1790s to Interstate 81, roads—whether trails, paved, or rail—have made the area easily accessible from any direction.

IMAGES
of America

CORTLAND COUNTY

Mary Ann Kane

ARCADIA
PUBLISHING

Copyright © 1999 by Mary Ann Kane
ISBN 978-0-7385-4453-3

Published by Arcadia Publishing
Charleston, South Carolina

Printed in the United States of America

Library of Congress Catalog Card Number: 2005934875

For all general information contact Arcadia Publishing at:
Telephone 843-853-2070
Fax 843-853-0044
E-mail sales@arcadiapublishing.com
For customer service and orders:
Toll-Free 1-888-313-2665

Visit us on the Internet at www.arcadiapublishing.com

CONTENTS

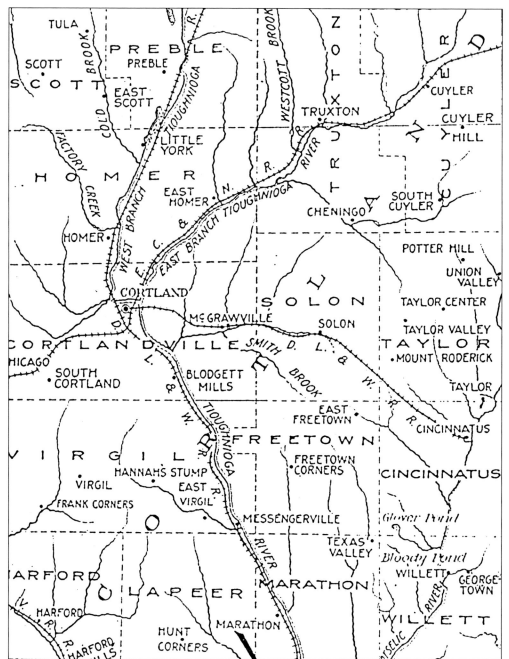

In 1782 the New York State Legislature set aside 1,680,000 acres to be used as payment for two regiments needed to protect the state's western settlements. Surveyors divided this military tract into 26 townships of 100 lots with 600 acres in each. One lot in each township was for the promotion of literature and one for support of the gospel and common schools. When Cortland became a county, included in its borders were the Townships of Homer, Solon, Virgil, and Cincinnatus, plus part of Tully and Fabius, and in the southwest, a piece of the Boston Ten Towns. The townships have subsequently been divided into 15 towns, three incorporated villages, and one city.

INTRODUCTION

"They came into a delightful region . . ." The first recorded reference to what was to become Cortland County is in the diary of German Palatine Conrad Weiser, in an entry dated April 9, 1731. Weiser was an interpreter of Native-American languages for the government of Pennsylvania, and during the French and Indian War he was instrumental in keeping the Iroquois allied with the English. Prior to 1746, he made three trips through this territory, calling Virgil's hills the Gooseberry Mountains and noting that Native-American legends placed Mount Topping as the location where corn, pumpkin, and tobacco first grew.

Although the organization of the Iroquois Confederacy c. 1570 included this area in the Onondaga tribe's canton, it has been known more for the location of Lenai Lenape hunting camps rather than for longhouses. According to historian/author H.C. Goodwin, the Lenape word for "bank of flowers" was given to the county's Tioughnioga River.

In 1615, Samuel de Champlain sent his Lt. Brulé south from Onondaga Lake to enlist the aid of the Susquehannas in the French's fight against the Iroquois. Brulé's route took him through the heart of New York, but he may not have been impressed by the endless forests, as he returned by another way.

By 1791, we began to make our own history. The Military Tract had finally been surveyed, townships were named, and the state lottery was held to determine land ownership among veterans. Awards of 500 acres for the enlisted men and up to 5,500 acres for officers did not inspire a land rush. Only 16 of those people eligible to draw the acreage settled on them, although at least 150 Revolutionary War veterans found their way here from Massachusetts, Connecticut, and Rhode Island.

The very first settlers in the area did not fit into either category, as Amos Todd and Joseph and Rachel Todd Beebe were too young to have participated in an 18th-century war. Travelling north on the river from near Binghamton, they first stopped where the Tioughnioga divides, before continuing along the west branch later on. Others would come from the east via Native-American trails. All came intent on extending their New England culture to this new frontier.

As the population increased, occupations other than farming became available. In the community of Port Watson, flat-bottomed boats (called arks) were constructed to carry produce, potash, maple syrup, and corn whiskey to markets to the south. Travelling in the boats took place annually in the spring, rather than year-round, as the weighty arks depended on the high water of the spring for ease of movement. Unable to maneuver back, they were destroyed wherever they had docked. The chain of rivers would eventually end up carrying Cortland goods to the Chesapeake Bay.

When the railroads crossed the county in the mid-1800s, factory output could be carried to many further destinations. So many different products were being manufactured in the county at the time that the lines were willing to carry less-than-car-load-lots to take advantage of the variety. These same railroads provided the coal that powered the factories.

Most of the original settlers of the area hailed from New England, but in the 1830s Irish immigrants began to arrive. The 1890s brought Southern Italians to the area, and by 1915 a wave from the Slavic nations arrived. Shortly after, Lebanese families began moving to the area. Employment opportunities were everywhere!

Although manufacturing is not quite as important to the economy of Cortland County today, positions in government, education, and service industries are, and as a result, a new immigration movement has developed, bringing about a new diversity and energy to this "delightful region."

One

BYWAYS AND HAMLETS

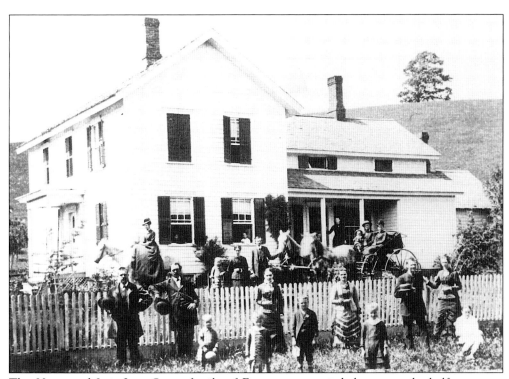

The Harry and Lois Jane Stone family of Freetown occupied the one-and-a-half-story rear section of their home in 1871–72 and then added the two-story front part in 1880–82. The decorative small porch came later. This 1893 photograph of the family and their animals is typical of poses in the late 19th century throughout Cortland County. It visibly documents how the Stones had prospered financially and increased in number.

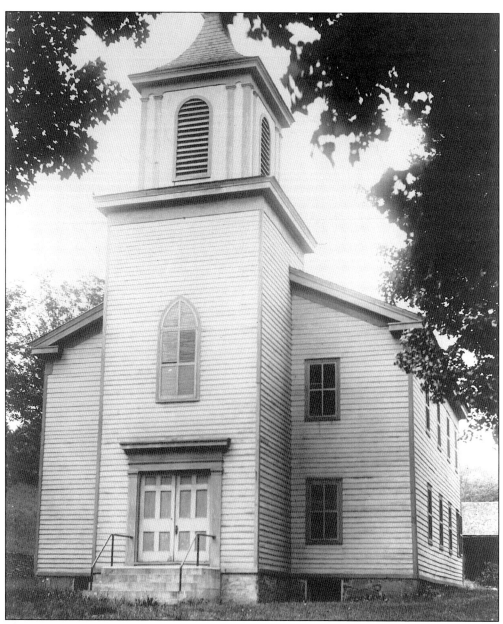

The Baptists had organized in Homer in 1801, and ten years later they held services at Lower Homer (the site of Cortland Memorial Hospital) in their first local church. Substantial in size, the building had no heating system, so families heated their pews with foot warmers from home. Pew gates helped preserve the portable stoves' output. During 1834 it was leased to the Universalists while their own church was constructed in Cortlandville. Then the church became portable, and was taken down piece by piece, numbered, and transported to Blodgett Mills by 12 oxen for the Methodists. It reopened c. 1840. In 1890 it reverted again to the Baptists. In January 1997, its members affiliated with Village Missions, a non-denominational supplier of full-time leadership in rural areas, and it is now the Church of Blodgett Mills. Few county structures can claim continuous usage for the same purpose for which they were originally built.

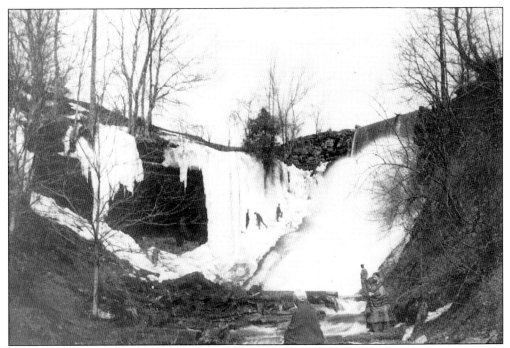

It has been called Cossett's Glen and Bennett's Falls, but is more likely to be recognized as Spicer's Falls on Trout Brook in Cuyler. A dam can be seen at the top where a sawmill stood until it was moved to the bottom of the falls, behind a gristmill. Later the gristmill was run by a motor and shared its facility with both a planing and a cider mill.

Gristmill operator and State Assemblyman Nathan Heaton's cobblestone home on theDaisy Hollow Road, Harford, was unique in the county as few employed this material in construction. Built between 1820 and 1840, efforts by the Cortland County Historical Society and others failed to save it from demolition to make way for a Cornell University agricultural project in 1973.

Presbyterians erected their building in Preble Center, a mile north of Baltimore, in 1831, but moved it to Main Street, Preble Corners, in 1859. In 1923, the church was raised to provide a sun-lit basement, and a Greek Revival frontage with columns was added. In 1946, the Presbyterians and Methodists joined as the United Church of Preble; in 1954, its affiliation was Congregational, and in 1961, it became known as the United Church of Christ. The steeple is lit at night, and can be seen across the valley.

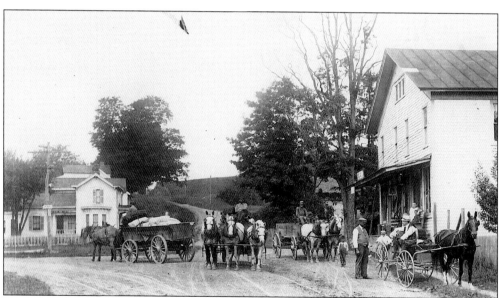

Just across the town line with Cincinnatus is the hamlet of Taylor (once called Bangall). North and west of it is the expanse of the Town of Taylor, Union Valley, Mount Roderick, and state reforestation acres. Carved from Solon in 1849, it is named for Mexican War hero General Zachery Taylor. That very year, he was campaigning for president as a Whig, with running mate Millard Fillmore, born at Summerhill in adjacent Cayuga County.

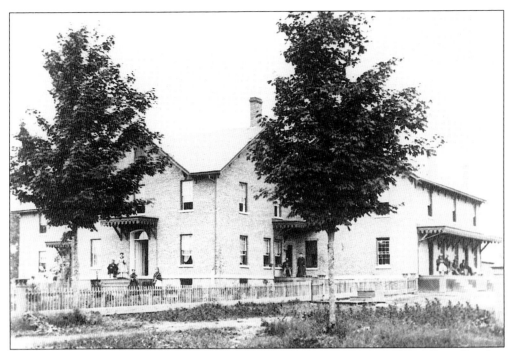

Until the establishment of the county's poor farm at Loring Crossing and East River Road in 1836, individual towns paid their citizens to assist the ill and indigent. This photograph of 1873 shows newly constructed housing that met the county board of supervisors committee's goal for a residence that was "substantial, permanent, and convenient." The fate of the complex—which includes an asylum, chapel, and barns—awaits determination.

On routes called Quail Hollow and Valentine Hill, drovers and stagecoaches crossed the Town of Lapeer, aiming for Marathon. A day's journey apart, hotels, inns, and taverns provided respite for travelers. At Hunt Corner, Lewis Swift's father-in-law employed him as a tavern clerk. Lewis followed his scientific bent by building a crude observatory with a revolving dome. He went on to become the head of Mt. Lowe Observatory in California and was noted for his discovery of 15 comets and 1,300 nebulae. He retired, blind, to Marathon.

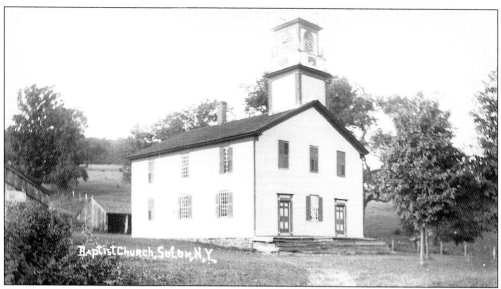

The Baptist Church on Route 41, on the approach to Solon hamlet from McGraw, was dedicated in 1835. Handsome inside and out, a gallery nearly circled the congregation, and blinds were painted green. The barn and horse sheds disappeared in 1911, but honey bees in the belfry continued. Worship occurred here into the 1980s as the Solon Independent Fundamentalist Baptist Church. Today the building is privately owned, converted to apartments, and the lack of shade exposes the shattered remains of tombstones in its cemetery.

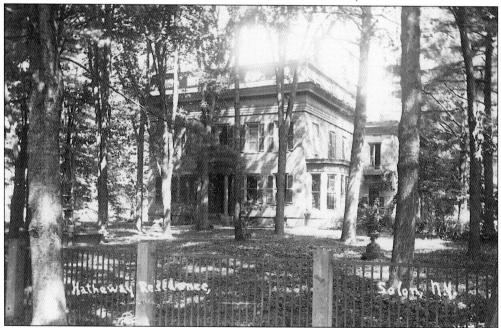

No individual defined a town more than Samuel Hatheway did Solon. A self-made man from Massachusetts, he was a major-general in the local militia, a lawyer, a jurist, and a member of the State Assembly and the House of Representatives. He helped subdue a potential assassin of President Jackson in the Capitol's rotunda. His home was made of stone found on his 4,000 acres, and though expanded on each side, the house itself remains relatively unchanged.

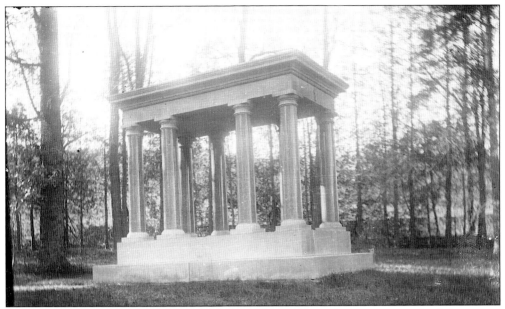

It took five railroad cars to bring 55 tons of Quincy granite and equipment to the Solon siding in 1905, when Samuel Hatheway's daughter Elizabeth decided to erect a Greek temple-styled mausoleum at "The Cedars," the family's private burial place on the estate. Eleven-foot-tall Doric columns were placed over the unmarked graves of eighteen family members, deceased from 1826. A tablet was affixed to list the names. Burials continue there to this day.

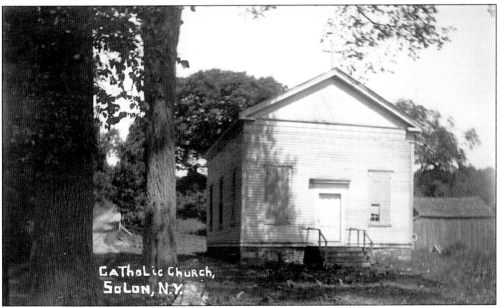

Pre-famine Irish immigrants owned farms in Solon, and others worked for the Hatheways. Irish boys wintered Erie Canal horses in the town as well, livening the season's social life. Samuel Hatheway gave his neighbors a small plot on Truxton Road where they built St. Bridget's Church in 1851, the first Roman Catholic church in the county. Later he sold a plot further along the road for their Maplewood Cemetery. The final service here was in 1919. The Town purchased it, later to lose it in a fire.

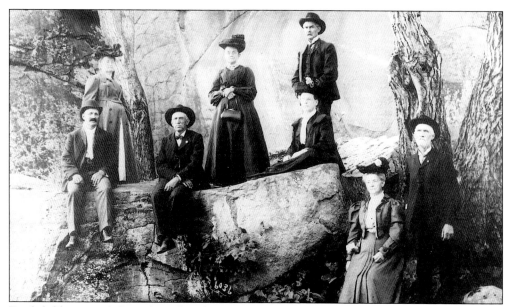

Battlefield tours of Gettysburg lured many veterans of the Civil War, and others, around 1900. Photographers specialized in capturing these solemn images. From left to right are the Ed Rindges of Cortlandville (he was too young to have served), East Homer residents John and Priscilla Beattie, John and Elizabeth Henry, and Eugene and Susan Burnham. Henry and Burnham were with the 76th NYV and Beattie with the 157th NYV. Both regiments suffered heavy casualties at Gettysburg.

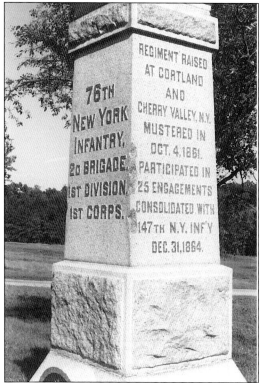

Gettysburg is dotted with memorials to the men who wrote the history of July 1–3, 1863. The 76th NYV was formed in Cortland County at the beginning of the Civil War, and encamped for weeks at "Fort Campbell," the site of the former fair grounds. The 76th was the first infantry group fired upon in this renowned battle. The 157th NYV, organized in Cortland and Madison Counties, is remembered elsewhere on the field.

Having borne several names first, the "Texas" part of Texas Valley was adopted in the mid-1800s, when the events in the American west were making headlines. The settlement supported three churches. The Baptist Church (1829) served as a school and still stands. This church was built in 1857 as Presbyterian, but in 1935 it became the Texas Valley Community Methodist. The churches were once joined by two general stores (one with a post office), cheese and butter factories, and more than 30 additional houses.

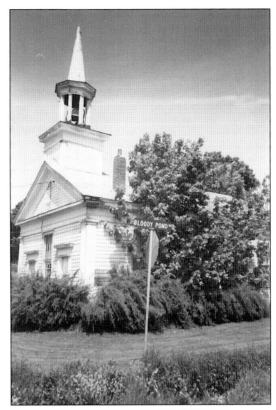

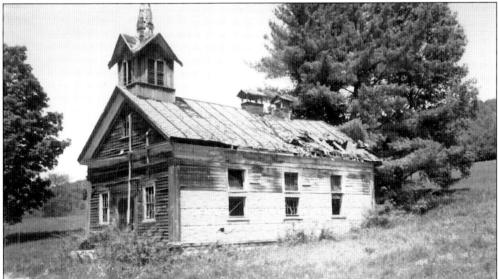

Once named The Center, Texas Valley had great potential for growth as it was where the Towns of Marathon, Willet, Freetown, and Cincinnatus meet. But the railroad went elsewhere, and so did expectations for the settlement's future. This 1993 picture of the 1864 Methodist Episcopal Church does not show that the belfry has since fallen through the roof. In December 1904 it was drawn across the road, where it came off the track. It stood where it landed until April 1905. The belfry was installed when it reached this destination.

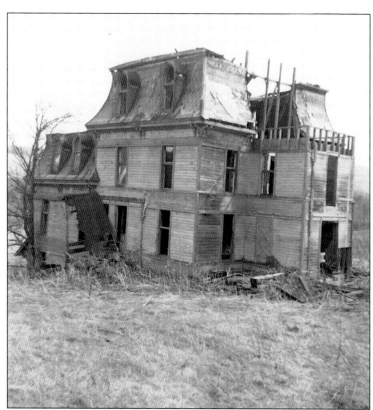

Whatever possessed Wilson Green to construct a 42-room house after his wife died is a great mystery in Willet. Constructed on 450 acres with a fine spring, it was on the west side of the Otselic River, near the covered bridge. It boasted four stories, 39 of its rooms had closets, and there was stained glass on the first floor. It was last occupied in 1952, and has long been gone from the scene.

Five miles square, the Town of Lapeer was separated from the Town of Virgil in 1845. Lapeer's first settler, Primus Grant, a native of Guinea, arrived in 1799. It is reported that he traveled to visit George Washington to discuss the land rights of Revolutionary War veterans, 16 of whom are buried within the town's borders. Although commercially handicapped without a railroad, lumbering, dairy farming, and associated farm businesses did develop, with horse breeding and camping remaining important businesses today.

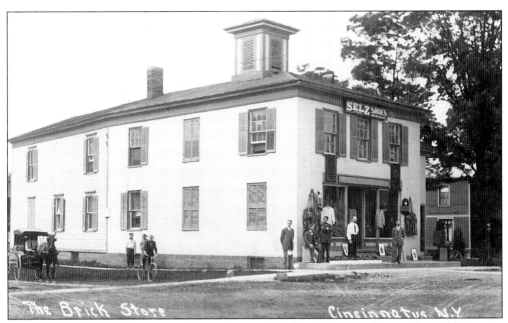

The Brick Store in Cincinnatus featured a men's haberdashery, and a wooden addition. Its wares hang outside and in its window display. John Kingman, who came in the mid-1790s, was responsible for the first store (where the Brick stood), first inn, and first school. The town was named after Cincinnatus, a Roman dictator of 456 BC.

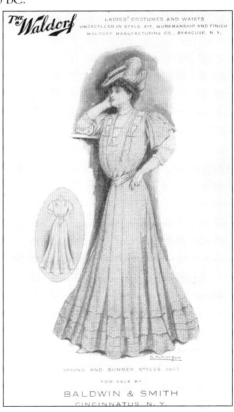

The advent of the railroad and the incorporation of a local bank in the late 1890s brought business advantages to Cincinnatus, as evidenced by the Victorian homes on the route to Taylor in the historic district. Baldwin and Smith advertised Waldorf fashions by postcard in 1907, pointing out that their brand of costumes and waists (blouses) was unexcelled in fit, workmanship, and finish. Whether men's or women's clothing, advertising by mail or display was important even then.

19

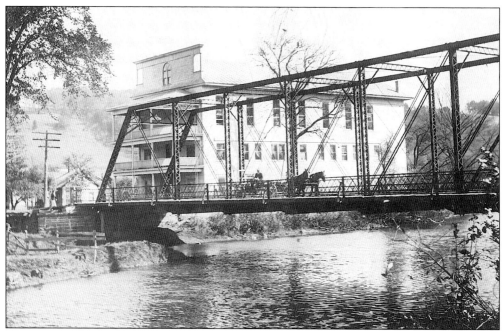

A covered bridge, lighted by kerosene lamps at night, was replaced by this 170-feet-long steel bridge in 1903, which in turn was replaced in 1951. Behind it is Taft and Gardner's New Opera House of 1913, later the Cincinnatus Hotel and "The Alhambra." Originally a feed store shared first floor space, the Tafts lived on the second floor, and the third floor was a ballroom.

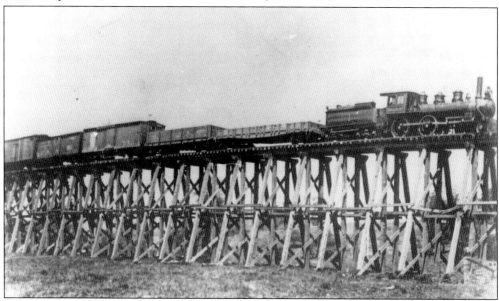

In the 1870s, the Utica, Chenango and Cortland Railroad began building a roadbed to Deposit. By the time Cincinnatus was reached, the funds had run out and rails and stock could not be afforded. It wasn't until 1898, as the Erie and Central, that cars began to roll, meandering finally to Cincinnatus. This wooden trestle was on a curve at Gee Brook and measured 850 feet long and 34 feet high. It was reinforced with earth in 1905. Any wonder that this route was known as the "Gee Whiz"?

Tinker Falls is part of the Labrador Hollow State Nature Preserve, located 4 miles north of the unincorporated village of Truxton. Shown here in 1890, the falls are an impressive natural rock amphitheater some five stories high. They are located on a small stream in the southeast section of the preserve, where spring thaws create a memorable flow. This area is also not far from the Morgan Hill State Forest.

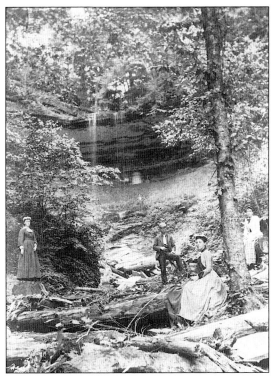

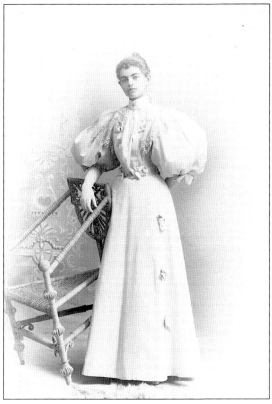

Little girls' wardrobes were rather limited. A dress for school and a dress for church was common, and both may have been hand-me-downs, even in a family of means. Bertha Wiegand was the daughter of Truxton druggist John Wiegand. Although she never married, she could always look back to her eighth grade graduation when she had the opportunity to dress in the highest style, as lovely as any bride of the 1890s.

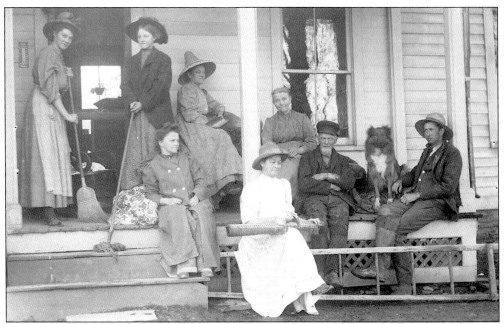

Housecleaning was as good an excuse as any for a family photograph at Frank Corners in 1910. DeVolso and Lydia Morgan Hotchkiss were born on adjoining farms. Two of their daughters married members of the Gee family, another Virgil family with deep roots in the town. At 80 years, DeVolso cared for 100 hens and Lydia continued to make butter for sale, but help around the house was probably always welcomed. (Photograph from Frances Bays, Virgil Historian.)

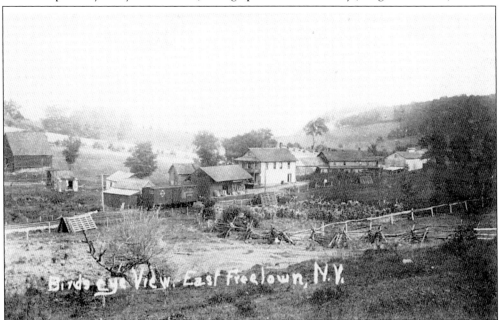

East Freetown was a hub for farmers in the Town of Freetown. With a railroad station, store, post office, milk station, and cheese factory, it provided an outlet for their products and a connection to the rest of the world. The name "Freetown" is credited to the first settler in the area, Samuel Hatheway, who came here in 1808 from a town in Massachusetts of that name.

Lydia Ackerman Taylor peers through the ripe rows of corn in the early 1920s. Corn and cabbage were important cash crops in the county, especially in the Preble Valley before highways disrupted the land. Corn was important from Cortland's beginnings, as it was ground for meal used in the home, and for corn whiskey—a popular river export.

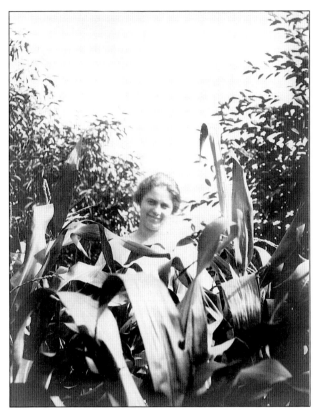

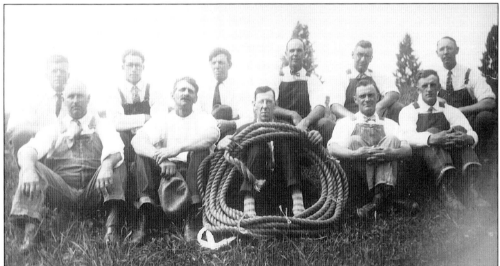

In 1803 a road replaced the marked trees in the valley between Homer and Scott. At the end of the 1800s, many families moved to "town" and sold to those whose hillside farms had not fared as well. By 1935, the successful Old Scott Road farmers shown here had become prominent. From left to right are as follows: (front row) F.E. Beck, C. Hammond, W. Forbes, H. Button, and A. Webster; (back row) C. Bee, L. Bartlett, F. Hodgson, J. Jones, H. Keep, and H. Jones. Driving top-of-the-line automobiles, a regular parade formed from their farms on Sunday morning rides to church in Homer.

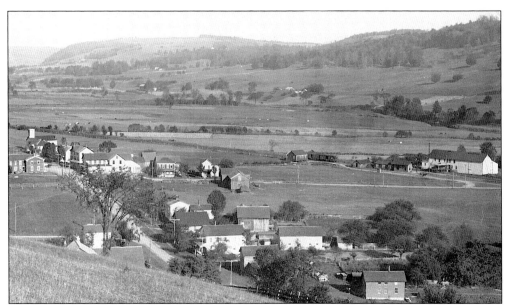

The beauty of the county's valleys can be ascertained from this view of East Homer. The east branch of the Tioughnioga River cuts a path at the foot of the rolling hills, its west branch is on the other side of the hill in the foreground. Thousands of years ago glaciers forced their way south; when they receded, they left deep gravel beds, rich farmland, and rivers, which today are barely reminders of their once powerful selves.

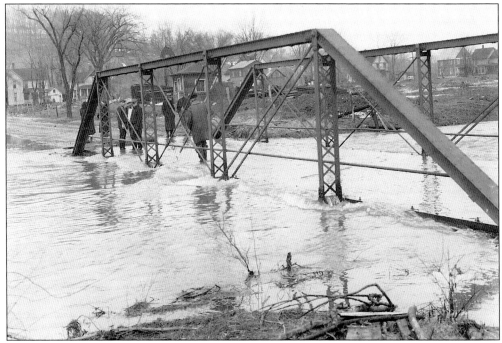

The rage of the Tioughnioga River in its spring flow southward swamps one of the many bridges through the narrow valley between Cortland and Marathon in the 1930s. This photograph was taken by a newspaper photographer who himself was not certain what community he snapped along Route 11. Larger bridges now tempt the Ti.

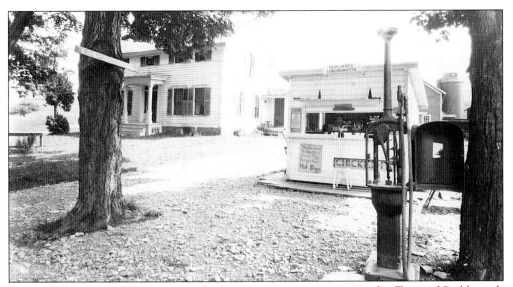

The early history of Baltimore reveals that it was an active spot in the Town of Preble with a tannery and shoe shop, a post office, a hotel, a brickyard, and a schoolhouse. But during a winter's storm in the early 1930s, traffic was literally halted for three days. Just north of Baltimore, even a snow plow operator was stranded in the Blue and White Luncheonette, or "hotdog stand." The number of men far exceeded the space, but it gave protection until the plows broke through.

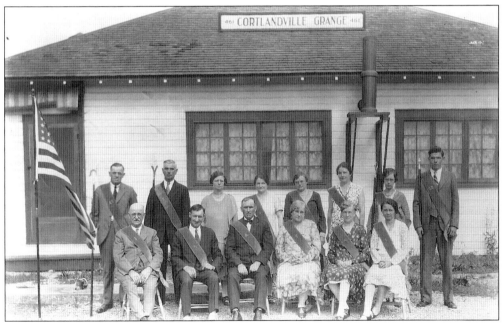

In March 1928, a tearoom and dance hall was built next to the brick schoolhouse (at the northeast corner of Routes 222 and 281). The resulting "Ringwood," thrice-sold after a burglary, had a customer in 1930 take an ax to the dining room! Upon investigation, illegal slot machines were found there. In April, the Cortlandville Grange bought and reconditionedthe building. It is possible that this mid-1930s picture may be connected to the 1936 mortgage burning.

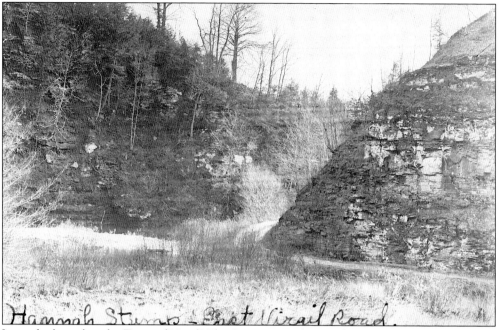

Hannah Stump - East Virgil Road.

Legends abound in the Town of Virgil! Elm Stump, a settlement between Cortland and Virgil, received its name from the felling of a giant elm, supposedly honey-filled. The axe wielders were disappointed, but the stump, large enough to hold two horses, reputedly became a community meeting place. Hannah's Stump, an outcropping 60–70 feet high on the Virgil-Messengerville road, is where Hannah Throwbridge threatened to jump if Isaac Bloomer didn't choose to marry her (he did).

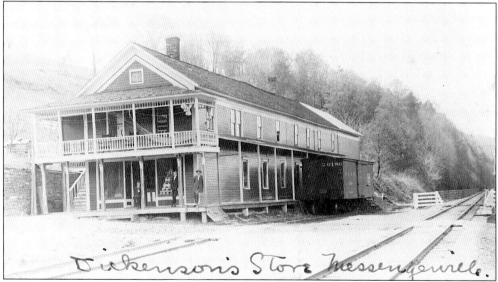

Dickenson's Store Messengerville.

When Joseph Chaplin was laying out the State Road from Oxford to Cayuga Lake (1792–96), should we be surprised he chose to settle in the "narrows" of the Town of Virgil rather than the hills? Joseph had married the widow Messenger, hence the settlement's eventual name. After the loss of the railroad and the post office in the 1930s, population, too, was lost in this Tioughnioga River settlement, north of Marathon.

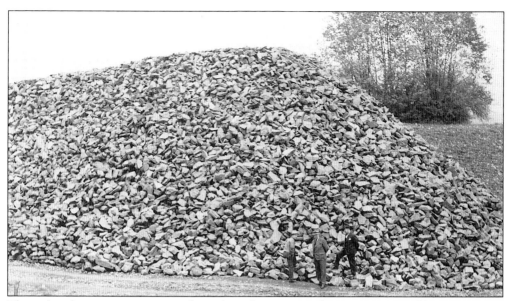

The railroads were exiting areas where dairy farming was the major source of income. To get milk off their farms, farmers relied on tanker trucks, which needed decent roads to reach the farms year-round. The enormity of the road building situation is documented here, where part of 7,000 cubic yards of stone quarried by WPA workers is visible. Highway Superintendent Bill Dwyer appears in this 1937 photograph.

Looking north on Route 11 toward the city of Cortland, with the valley of the Tioughnioga and the Virgil hills to the left, we travel the improved road of the 1930s. Elsewhere along the road signs warn of rock slides and deer crossings where floods and snow also threaten. Today, high above this scene, traffic speeds by on Route 81, unaware of the slower alternative.

The Cincinnatus Congregational Church was completed in 1832. It had double front entrances and box pews with doors. In the 1880s, the church was enlarged, pews were removed, and the pulpit end of the building was reversed. Cast in Albany, a bell was hung on a framework on the grounds until a spire was finally added. Problems maintaining attendance left the building empty and open for sale. The Cincinnatus Area Heritage Society was formed to again give purpose to this handsome building.

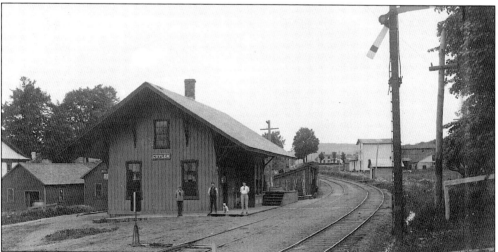

Sadly, as railroads went out of the lives of the hamlets, so too did most railway stations. Few were preserved. This one in Cuyler, built in 1872 by the Midland Railroad, is now occupied by the Cuyler Historical Society as a museum. The Town and community of Cuyler were named for Colonel John Cuyler, a medical officer who served during the Seminole and Creek conflicts and in the Mexican War.

Two

VILLAGE VIEWS

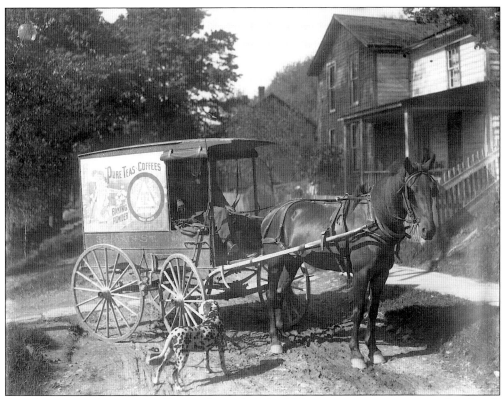

An advantage to living in a village at the end of the 19th century was a main street lined with shops, offering choices to the customers. Families there were accustomed to the delivery to their homes of ice and milk, and with the advent of the telephone, grocery orders could be called in and delivered. John Miller clerked at the Grand Union and is captured here on film in 1905, catering to homes on River at Pine Street, Homer.

Teacher Joshua Ballard built this house at the corner of Homer's Main Street and the Albany Post Road where it could easily attract customers to his tavern. "Wisdom's Gate" was a temperance tavern run from the 1840s until 1873 by its most famous host, George Washington Samson, and his son. Later it was a grocery store with entry by the corner door. The Braeside Tearoom occupied the premises in the 1930s; since then it has been an attractive residence.

Mechanics Hall was an immense building at the southwest corner of Main and Cayuga Streets in Homer, sitting in front of the Baptist Church. It was rumored to be able to house at least 40 families, but its uses varied. Andrew Dickson White and William O. Stoddard (who became a secretary to President Lincoln) attended Miss Trowbridge's Dame School in its basement in the 1830s. For a short time in the 1850s a room was outfitted for the offering of Mass by circuit riding priests.

It is ironic that the likenesses of men who brought youthful energy to the early settlements were seldom painted or photographed until their old age! Jedediah Barber (1787–1876) successfully operated his Great Western general store on Homer's main thoroughfare. His 1828 investment in the possible construction of a railroad through his adopted town led to severe financial losses, but was an example of his vision of what would make Homer prosperous.

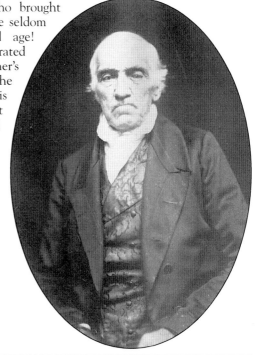

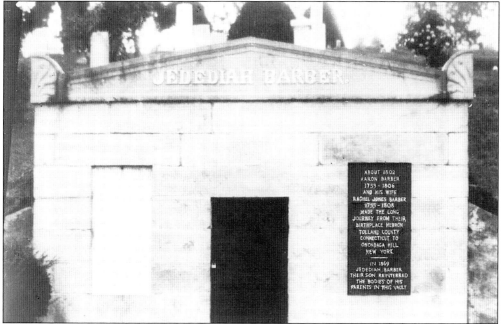

As the village of Homer's population grew, so did that of the cemetery behind the Cortland Academy, near the Green. Paris Barber offered land for this purpose in 1862. A born horticulturalist, he prepared designs for an elaborate garden with an ornamental gateway. Donations were scant and plans were changed, to be partially realized through the interest and funds of George Brockway in this century. Prominent on the hillside is the mausoleum of Paris' ancestors.

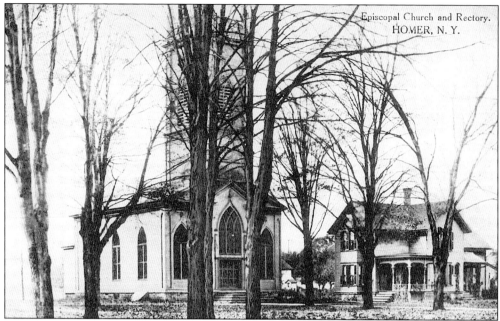

Calvary Episcopal Church is the furthest north of the churches on Homer Green. It is an example of Gothic Revival architecture, built of wood in 1831–32. It is the only original church building on the Green, although in 1931 it was lowered and the tower was rebuilt. The rectory was lost in a suspicious fire. Activities take place in an adjacent parish building.

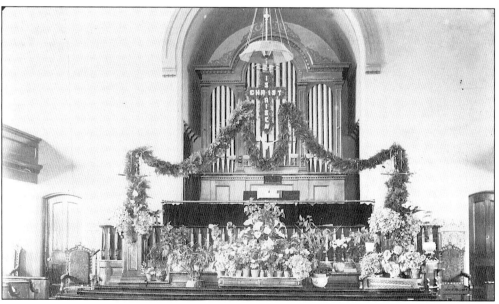

Members of the Congregationalist Church, organized in Homer in 1801, dedicated their church in 1805. The Colonial-style building seated up to 900. In 1863 a new church arose. Its interior is shown here, decorated for a turn-of-the-century Easter celebration. The year 1972 began with the interior in ruins from fire and basically only the massive timbers, petrified with age, recognizable. Without hesitation, reconstruction work began, with more than admirable results!

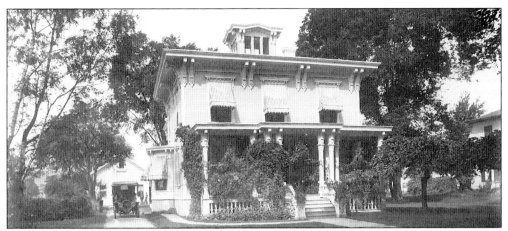

In 1869, historian H.C. Goodwin described this Homer residence of J.L. Boorum (the proprietor of the Flax and Cordage Mill) as, "undoubtedly the handsomest and most costly private frame residence in the county. It has 17 rooms of extensive proportions and every apartment is furnished with exquisite taste." The rooms were warmed by hot air, and both warm and cold water were available from cisterns and reservoirs. The home has since been called the Murray House and the Van Miller House, for past inventor residents.

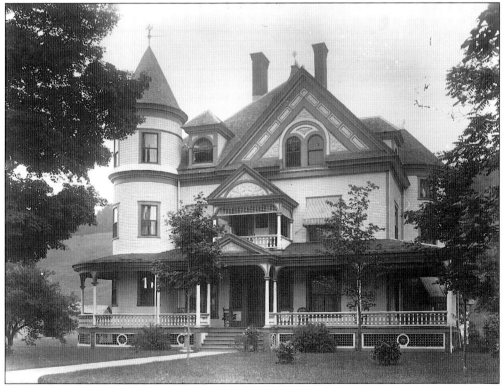

This Queen Anne-style house was built just north of Homer on East Little York Road (Route 11) in the 1890s and was elegantly furnished by the Murray family. Later known as "The Buckingham," it was an inn for two years managed by a noted hosteler, Reuben Buckingham. The barns and outbuildings were as elaborate as the house, which was destroyed by fire in the mid-1920s.

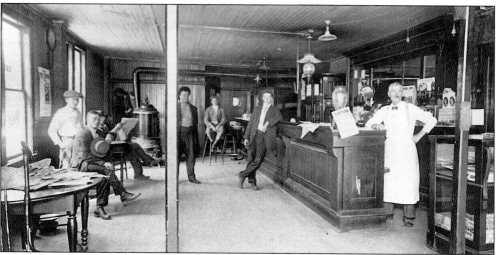

Francis "Dasher" Cox Sr. opened his saloon in Homer in 1905. When Homer went "dry" in 1911, business continued at the corner of Main and James Streets, but as a restaurant. "Dasher" ran the Arcade Café on Central Avenue in Cortland from 1915, and there his son Frank learned the trade. Returning to Homer at "Cox's Corner," the younger "Dasher" held court in his own restaurant and taproom. The specialty of his menu, into the 1960s, was lobster dinners.

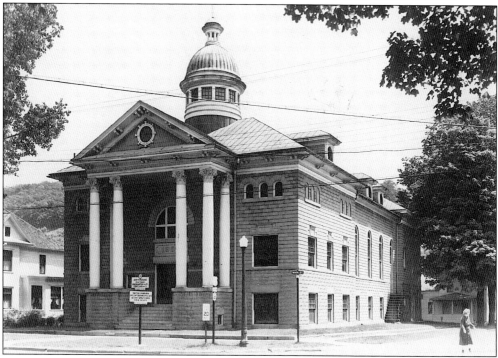

Directional signs would indicate that all roads lead to this spot or that this corner is the center of the community. A bit of both is probably close to the truth. The offices of the Town of Homer and Homer village are located in this municipal building, along with the David Harum Senior Center. Finished in 1908 with a large auditorium, local and traveling shows performed on its stage. The Capitol Theater showed movies here into the 1950s, while a large marquee projected out from between the pillars.

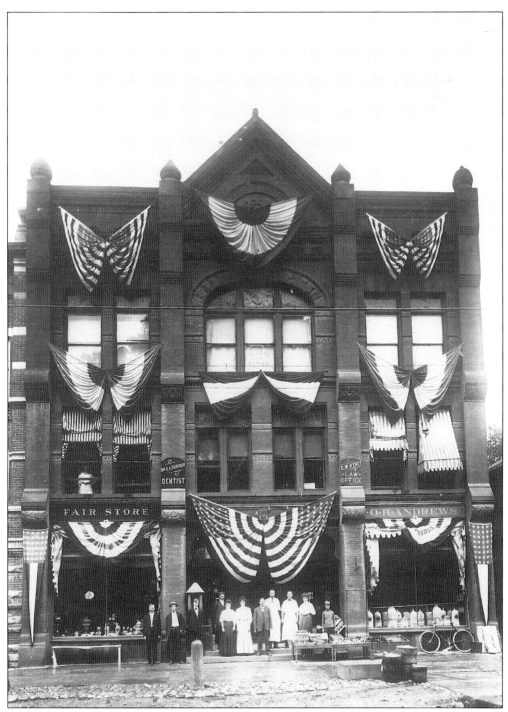

The Brockway Block in Homer is probably decorated for an Old Home Day celebration, *c.* 1910. The Fair Store supplied shoppers with housewares (note the china items in the window), while Andrews handled groceries. Deliveries from here would have been made by bicycle. William Crandall managed the Fair Store, which also went by the name of Yager and Crandall.

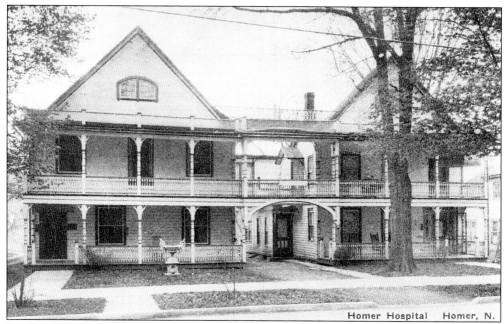

Homer Hospital Homer, N.

In 1888, Mrs. Marguerite Hakes established a sanitarium in her home at 45 South Main Street, Homer. Its new career as the Homer Hospital began in 1914 with an addition built to accommodate 25 to 30 patients. With facilities for operations, X-rays, and obstetrics, a private room did not exceed $15 per week. Mrs. Hakes, as matron, supervised its nurses' training school. In 1926, George Brockway bought the hospital to give its property to what is now the Elizabeth Brewster House.

The Fair View Health Camp was incorporated in 1924 and was located on 7 acres on a hilltop just north of Homer village. It was run during the summer for county children considered susceptible to tuberculosis. Beginning with 25 participants, the camp's quarters were soon expanded for 60. Support came from its board, Rotary club, Christmas Seals, the Community Chest, and other fund-raisers, as campers were not charged. It was sold in 1953 at auction.

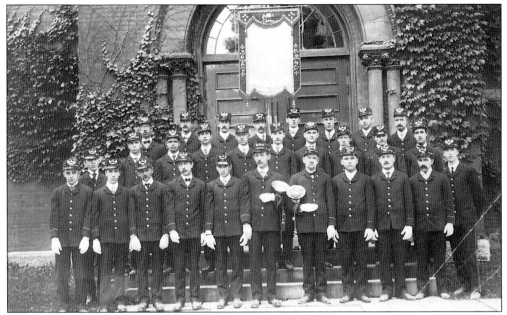

The Homer Fire Department officially organized in 1873 with a steamer and a hose company for its James Street station. Water for the volunteers to combat fires came from fire wells until 1887, when water under pressure in hydrants could be obtained. In the summer of 1882, Tioughnioga Co. No.1 disbanded, and most formed the new Orient Hook and Ladder Co. No. 5, shown here in front of the Homer Academy. (Photograph loaned by Ruth E. Lindberg.)

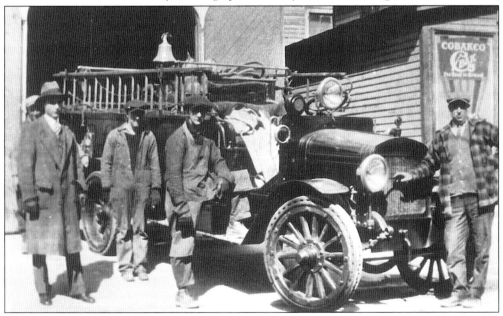

The first motorized engine for Homer's volunteer fire department was acquired in 1920. A chain drive Brockway and a homemade Cadillac hook and ladder were stored in the James Street firehouse and were employed into the 1930s. As trucks grew in size and number, a new station was called for. Located on part of the old hospital's land on Main Street, the 1941 station has since been enlarged.

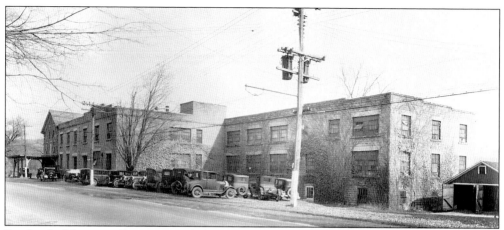

Sandwiched between Route 11 and the Tioughnioga on the southern edge of the village of Homer was the Newton Line plant. The company was founded in 1908 by De Vaulson D. Newton and his son Dan, and was incorporated in an 1837 gristmill. It gained fame for its silk, cotton, and linen fish lines, and after World War II, for its synthetic lines. As demand for their lines increased, additions were made to the building. When no more riverbank was left, operations moved across the highway.

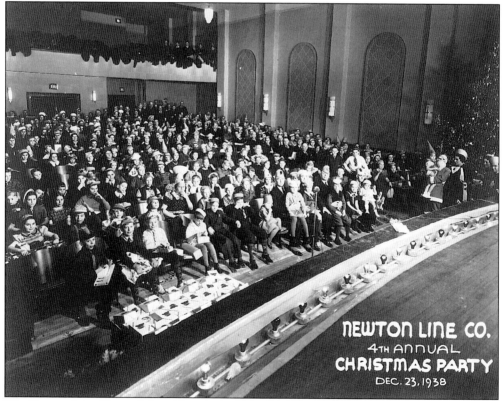

NEWTON LINE CO.
4TH ANNUAL
CHRISTMAS PARTY
DEC. 23, 1938

The Newton Line Co. prided itself on the length of time its workers had been employed there as well as being locally owned and operated. Family Christmas parties held in the auditorium of the town hall were for many years management's way of recognizing those two factors. World War II production interrupted this practice.

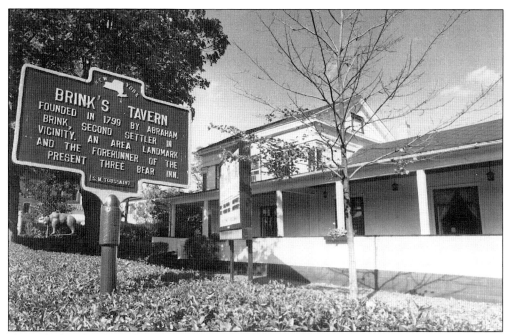

If one looks closely under the state's historical marker, at least one bear can be seen outside Marathon's Three Bear Inn. Abraham Brink's tavern here was a loghouse. His son built what is now the northwest section of the inn, said to date from 1825 to 1845. Brink's Tavern remained in the family for 124 years. It was the Forshees from McGraw who hung three bear skins from the porch in the 1920s, and sometimes exhibited bears while they owned it.

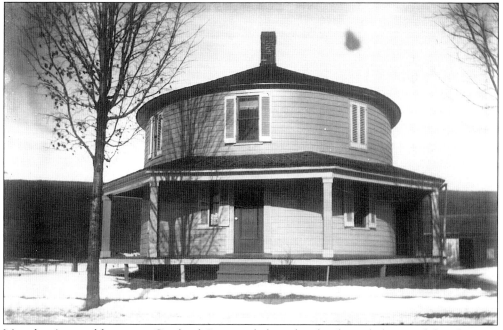

Marathon's round house on Cortland Street is believed to be the only house of this shape in New York State. It was constructed in the 1860s by Joseph Conger, who was a cooper; his occupation may be the connection to the architecture. As time passed, so did the porch.

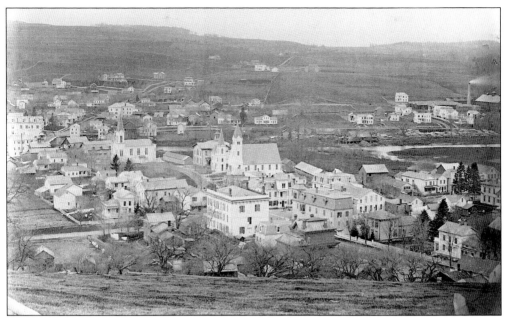

This photograph was taken before September 4, 1884, as a fire took out three businesses and a house on the northeast corner of Main and Cortland Streets that day (Cortland Street runs parallel to the river). The fire threatened the entire village. A special train from Whitney Point brought in a steamer to supplement the hand pump and bucket brigade.

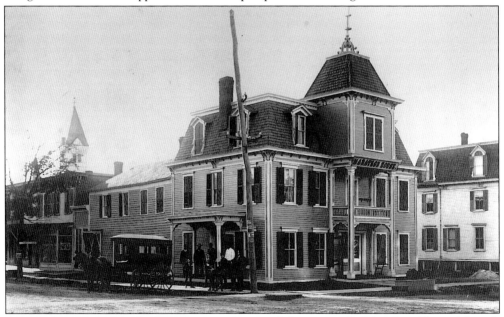

Seen in the center of the bird's-eye view at the top of the page is the Marathon House (above). In 1833, David Peck purchased a small dwelling at the corner of Main and Cortland Streets and erected an addition to house a tavern. Successive landlords altered and improved the structure. Adding mansard roofs to flat-roofed buildings gave them an extra usable floor. The mansard style was popular in the 1880s and '90s, and Marathon has a street above the river with many homes with this feature.

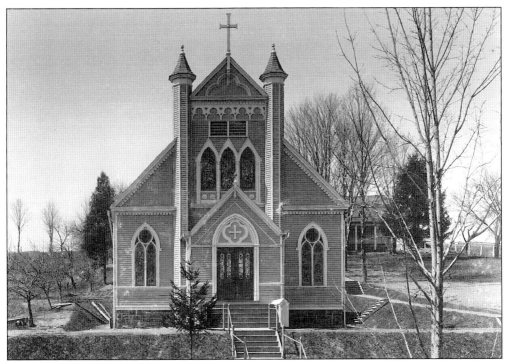

Services for Roman Catholics in Marathon began in 1853 in homes visited by clergy from Norwich, Cortland, and Binghamton. In the 1870s the Presbyterian Academy was purchased and remodeled for a chapel seating 300. On the same property in 1896, the cornerstone was placed for St. Stephen's Church, designed by acclaimed Syracuse architect Archimedes Russell.

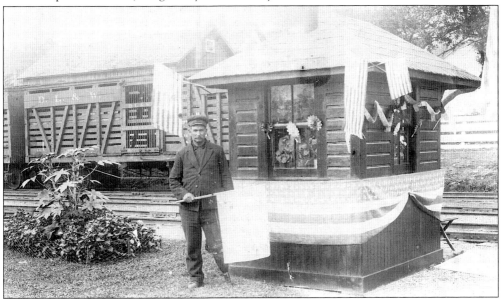

Even the watchman decorated his shanty in Marathon in celebration of the Fourth of July, 1901. Nearby is a small, chicken wire-fenced garden he cultivated between trains alongside the Delaware, Lackawanna, and Western's tracks. Built on the west side of the river, the line stimulated the growth of the community.

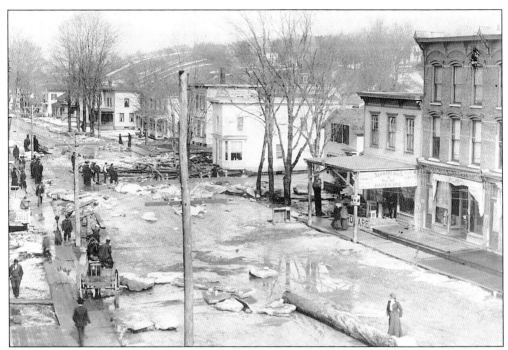

Ice chunks and debris clutter East Main Street, Marathon, following the flooding of the Tioughnioga in 1902. This was not the first or only water disaster, and none may have equaled that of the summer of 1935. A cloud-burst turned creeks and the river violent. Houses were totally destroyed, foundations swept from even the most substantial buildings, bridges undercut, and two lives lost.

The Methodists date 1842 for the completion of their 36-by-40-foot Marathon church. In 1895 a steeple was struck by lightning and the next year the steeple and chimneys were blown off in a wind storm. It was moved, with its new stained-glass windows in place, from its foundation to a lot across Main Street in 1931. This enabled the school district to add a new gym and auditorium to the high school.

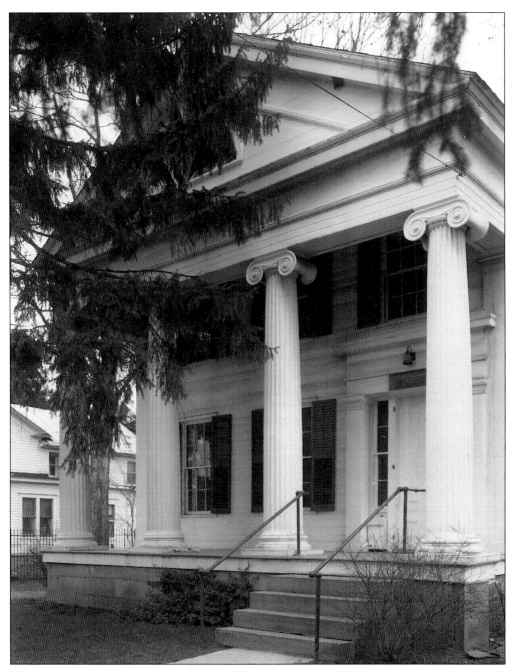

Daniel Scott Lamont (1851–1905) grew up in this Greek Revival house on the north side of Main Street, McGrawville. The rear section dates to 1813. Opportunities for elective office were many for him, but he chose to aid the political careers of others. He clerked for Governor Tilden, was a military and private secretary for Governor Cleveland, and was a private secretary and secretary of war for President Cleveland. He frequently visited his family here, and it was his wife and daughter who were responsible for the conversion of the home into the village's library. Lamont was responsible for the area's Civil War veterans' gift to the village of Cortland of two cannons, which stand today at the entrance to Court House Park.

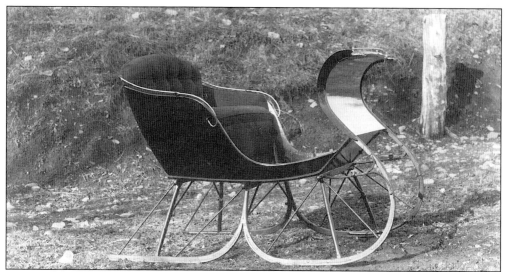

In the mid-1800s, nearly every settlement manufactured wagons and sleighs, if only one at a time by the business owners themselves. These means of transportation were major income producers in the larger county villages into the 1890s. The photograph is of a Russian Portland sleigh made at the Monarch Wagon Co. of McGrawville and patented in 1888. Its merits were advertised as "tipping prevented; avoids slowing; relieves the rider; and costs more but is sold for the same."

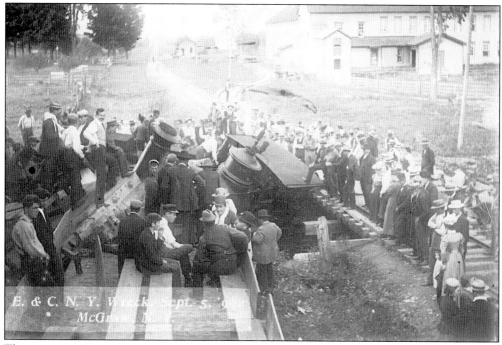

The train to Cincinnatus with the W.H. Tisdale engine was returning to Cortland on September 5, 1898, when the engine and tender plunged into Trout Creek in McGraw after jumping the track. A section crew had left open a switch after running a handcar onto a siding. The passenger car remained on the tracks, and injuries were sustained by the engineer and fireman. Notice the station agent, in the white shirt, sitting in the foreground.

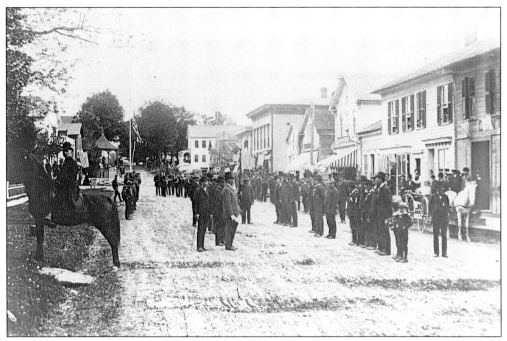

In front of the Lamont homestead, local dignitaries and Civil War veterans take part in Memorial Day exercises on Main Street, McGraw. The village band awaits its turn in the background. To the left of the flagpole, the village's bandstand, built over a creek in 1876, can be seen. Note the number of shops on the right in this 1890s picture.

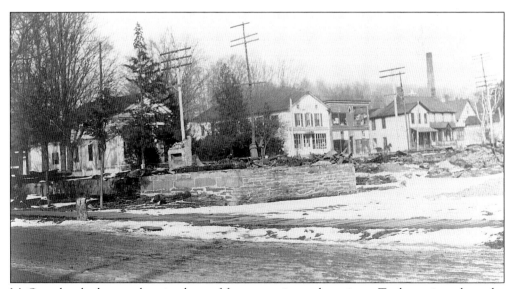

McGraw has had more than its share of fires, even in modern times. To determine where the photographer stood, note the Lamont house behind the evergreen (its the first building on the left). The property in front of it shows the results of the January 1906 fire that took out the long row of stores shown in the top picture on this page. Twelve enterprises were lost.

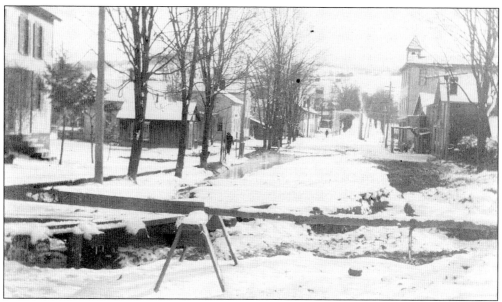

McGrawville was named for its first settler, Samuel McGraw, who arrived in 1806, and his descendants whose lives so influenced the area. The "ville" was dropped when the community was incorporated as a village in 1932. Floods have been a problem, as documented in this 1901 photograph taken while looking south from Main Street on South Street, not from the river but from the creeks. McGraw is moderate in size but has seven bridges.

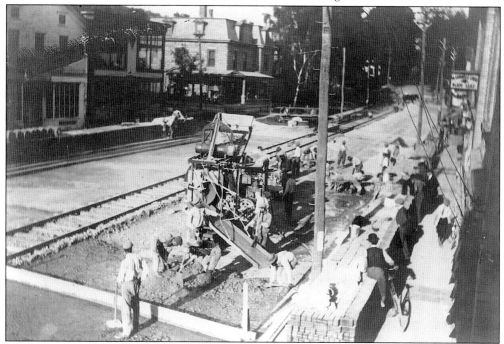

Might that be a Marathon Climax Road Machine preparing McGraw's Main Street roadbed for its new pavement? Bricks were laid on either side of the Cortland Traction Company's trolley tracks, c. 1910. The large house in the picture's center was built of "rock-faced concrete block" about 1906, and was home to Dr. F.H. Forshee for some 35 years.

Three

THE CITY

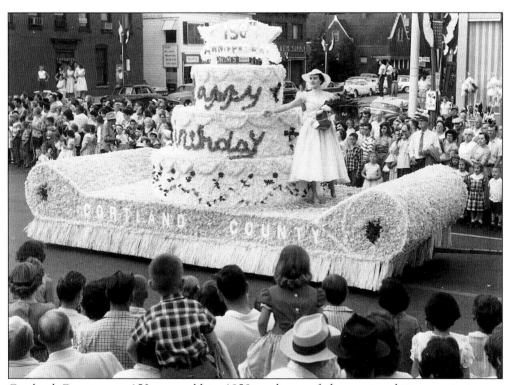

Cortland County was 150 years old in 1958, and one of the most ambitious projects ever was launched for a sesquicentennial celebration. From men growing beards as a tribute to their ancestors to the publication of a historical picture book, unity and pride were sparked throughout the county. Cortland people love parades, and perhaps the grandest of them all for the decorative lengths the floats achieved was held in the city that summer.

Of prime importance in 1808 when Cortland became a county was which settlement would be the county seat. Homer and McGrawville lost to Cortland, hardly a bump in a county road compared to the other two. The wood courthouse rose between today's Monroe Heights and Pleasant Streets on West Court Street. Thirty years later, an imposing new courthouse was built on the northwest corner of Court and Church Streets. By 1900, the columns had been subtracted and additions made, including a jail.

In 1893, a progressive education movement began in the village of Cortland, with the appropriation of funds for new schools. On Railroad Street (now Central Avenue) the new Central School welcomed students through grade 12. In 1923 a new facade, an auditorium, a gymnasium, and more classrooms totally changed the dimensions, as would other construction in following years. In the 1970s the county offices, plagued by over-crowding, adapted the school for use by county government.

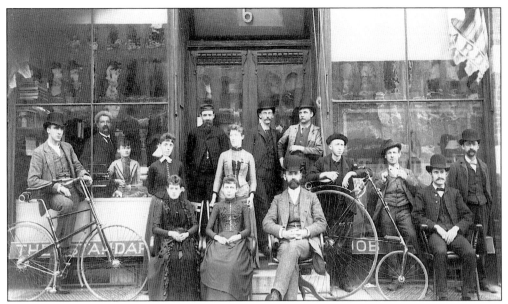

The roots of the *Cortland Standard* stretch deep, to a four-page weekly of 1867. Name, owner, and location changed until 1883, when its offices were moved to the present building, although at the time it did not occupy it totally. The staff is pictured in 1888, four years before the paper went to a daily. William H. Clark, seated in the front, was editor and publisher for 52 years. In time, McGraw's *Sentinel*, the *Homer Republican*, and the *Cincinnatus Times* were purchased by the *Standard*.

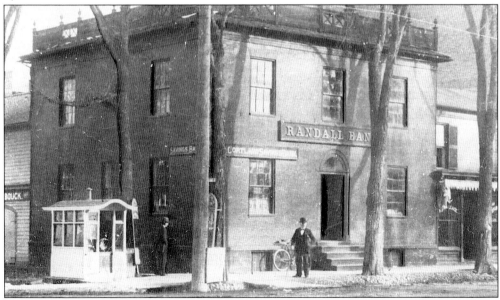

In 1824, at the southeast corner of Main and Court Streets, William Randall erected a bank building across the street from his estate. The Cortland Savings Bank would later be housed on the second floor of the structure, which was located where the Alliance Bank (formerly First National Bank) now stands. William's son, William R., stands in front, c. 1880. He preferred living on the second floor to residing in his mansion. The Brunswick Hotel is immediately to the right. Fire claimed the bank's successor, the Chocolate Shop, in 1953.

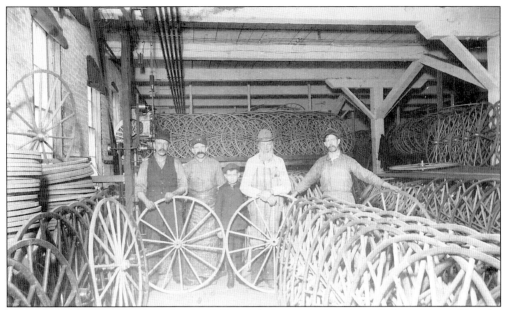

The Cortland Wagon Co. was Cortland County's first manufactory to do business world-wide, with a sales office as far away as New Zealand. Lawrence J. Fitzgerald began making wagons, carts, and sleighs in five attached buildings on East Court Street about 1880. In December 1888, the sprinkler system failed, and more than half of those buildings were destroyed. Fitzgerald immediately rebuilt and managed his company until motorized vehicles and debts saw him move on at the turn of the century.

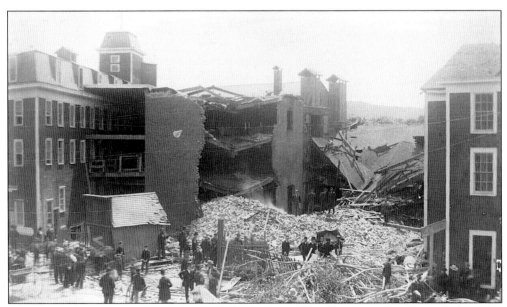

The second largest wagon company in Cortland was Hitchcock's, situated at the tracks between Elm Street and Clinton Avenue. In 1887 a boiler exploded in one building, killing an employee. The wagon company ended in the mid-1890s, after the owner was financially ruined by a scam artist who promised big results from a motorized bicycle.

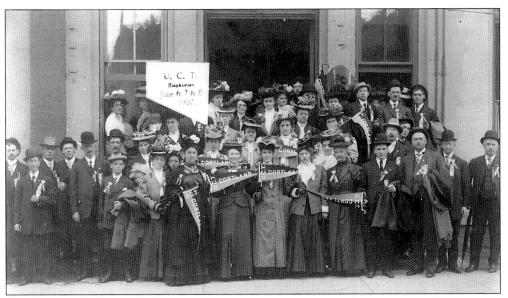

United Commercial Travelers is still a functioning organization that was initiated as a means for providing insurance to traveling salesmen. Members "dues" were premiums collected for payments to beneficiaries. This convention of members and their families does include at least one traveling saleswoman, Mrs. Alice Cately Ettling, who covered territory east of the Mississippi selling her father's inventions, which improved carriage rides. UCT membership is now available to anyone.

In spite of the statuary, G.F. Beaudry's store was advertised, *c.* 1900, as a stationery shop. Bicycles were eventually also sold here. In 1884 Beaudry did business at 17 North Main Street, enough so that he built his own block at 73 Main, Cortland, which is distinguished by the terra-cotta face of a Native American below the metal cornice and limestone name panel. Beaudry later produced wallpaper in the former Hitchcock plant.

Parenting was considerably different a century ago than it is now. Mothers dressed their sons and daughters alike until they were four or five years old. However, the weight of his fashionable costume does not seem to have spoiled the disposition of Lawrence Fitzgerald Lighton (1893–1961), named for his maternal grandfather. Gerald, as he was more familiarly known, would serve in World War I and live at 78 Tompkins Street, Cortland, the family home, for the rest of his life.

Gerald Lighton could look forward to more manly attire and activities, no matter how his mother dressed him. The ride for these gentlemen must have been pretty bumpy on those narrow wheels and stony road. However, dressed in the latest fashion of 1905 in a motorized carriage, they were certain to attract attention. Identified as A. Earl Bates' friends, only one is named—standing on the left is William P. Kane of Cortland.

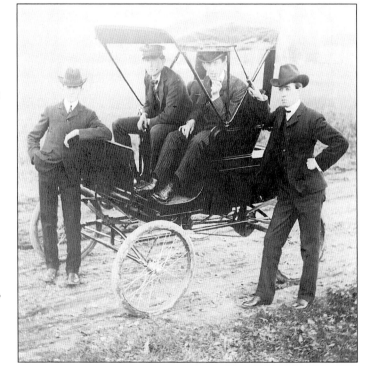

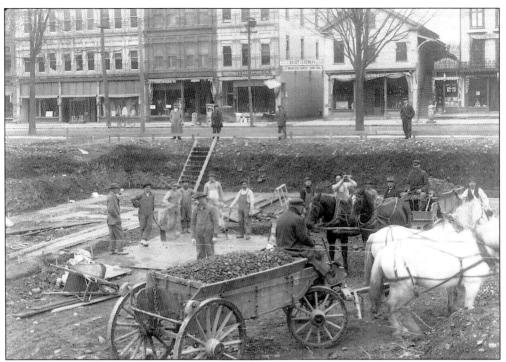

Cortland's post office moved about frequently. When the *Cortland Standard* had available first-floor space in 1883, the post office moved to the back end of the Tompkins Street side. There it remained until 1914, when the front lawn of the Billy P. Randall house (pictured here, with workers digging) became its own building's site. The post office was enlarged considerably in the 1930s.

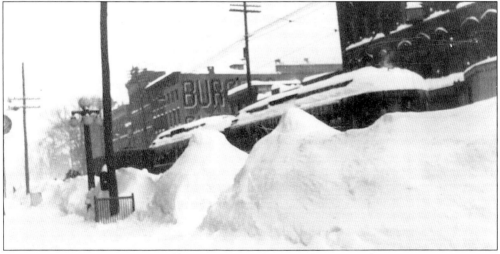

Who said we don't have winters like we used to? They could be right, when you see Main Street, Cortland, looking north from near the corner with West Court Street. Trolley tops are visible after the "Blizzard of 1914." The small cow-catchers on the front of the trolley car would provide a path for it along its tracks. Trucking curbside drifts to the Fair Grounds or to the river has raised environmental questions in modern times because of the use of chemicals to melt road ice.

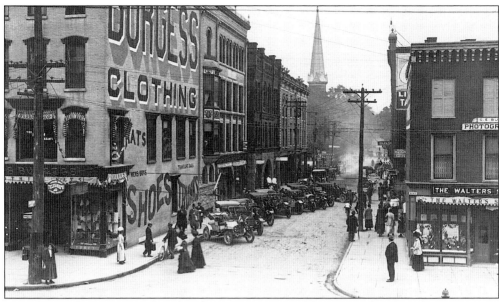

A 43-foot-wide extension of Railroad Street was opened between Church and Main Streets in 1886. It was renamed Central Avenue *c.1925*. Burgess Clothing sold men's clothing at this corner from 1887 to 1977, rebuilding after a fire in 1914. The darker facade on the left was where the Cortland Business Institute held classes, and the next along was, most recently, the Elks Club's meeting rooms. Note the steeple on what was the Baptist Church.

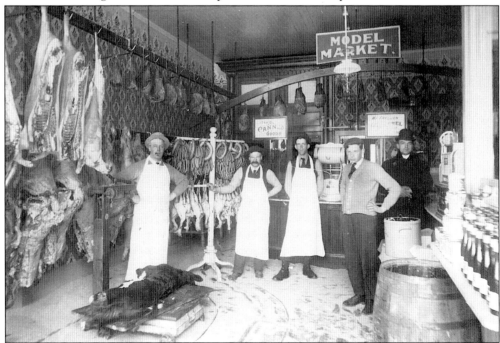

Emmett Reilly (left) stands with pride in his Model Market, 18 North Main Street, Cortland, about 1910. Practically a one-stop shop for groceries, there are a myriad of selections to see: the pork barrel, sauerkraut crock, hanging hogs, beef, hens, and sausages. A veal calf is being weighed above the non-slip floor surface, made so by sawdust.

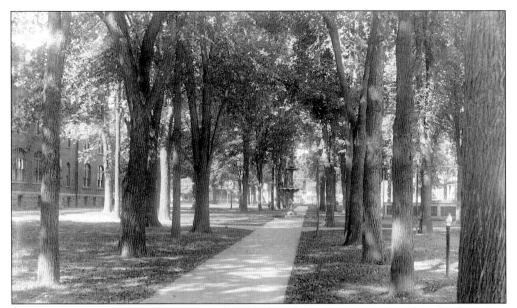

A walkway through the elms in Normal School Park, looking west, reveals a bandstand to the right and an elaborate iron fountain in the center. The park gained a new name after the loss of the school. The fountain was dismantled, stored at the Water Works, and possibly contributed to a World War II scrap-metal drive. The elms became the victims of disease and were replaced by maples.

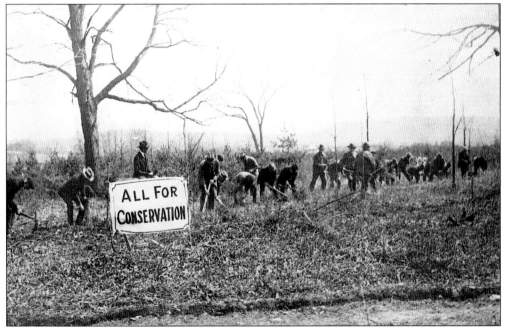

The Cortland Water Works Company began in 1884 at its present location. In 1899, its two pumps provided 3 million gallons daily through 17 miles of pipe to all parts of the village, with a reservoir above the Otter Creek station, at the top of Court Street hill. Preservation of the supply and purity of the artesian wells were the primary goals, and to meet its full potential, open land needed to be forested. In 1922, volunteers from the Rotary club aided in that project.

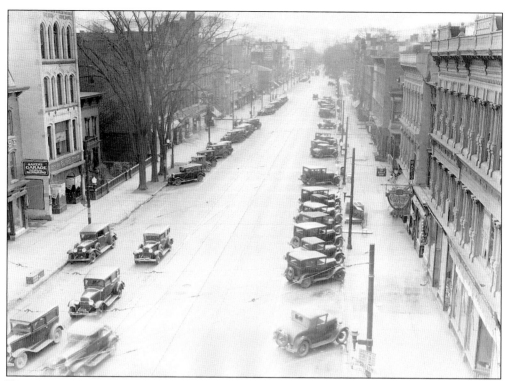

You may recognize many of Cortland's Main Street storefronts, but only one business remains with the same name and location after 70 years. Trees once lined "downtown." Those on the left shade the Keator/Chadbourne home, which dated from the 1850s. It survived damage from a neighbor's fire in 1884, and held out until 1937, when a new building replaced it and was leased to the W.T. Grant Co.

John McGuire ran "Jack's Cone Diner" at 34 Main Street, Cortland in the early 1930s. It was across from the Chinese laundry and near the southwest corner of Main and Maple Avenue. It was called the "Ice Cream Cone" soda fountain when it was struck by a car in 1935. In 1937 the Hulbert house was down; by 1939, the cone was too. Both were replaced by a gasoline station.

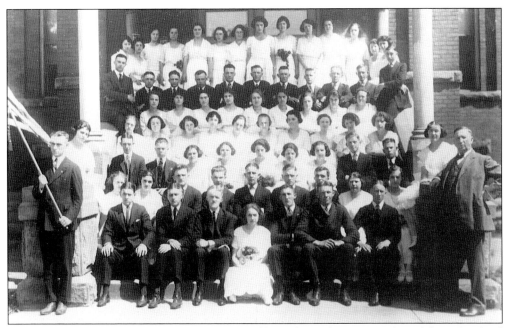

At the beginning of the 20th century, only small numbers of seniors graduated from Cortland Central High School, but the value of that diploma had increased by the time the class of 1921 assembled on the school steps with principal "Prof" Smith. Several of the young men were veterans of the First World War who had enlisted while in school and returned to finish their education. Eric Smith, holding the flag, was one. On the verge of the Roaring Twenties, the girls' long hair is safely netted to stay close to their heads.

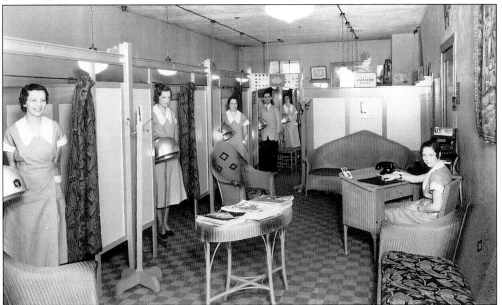

A dozen or so years later, style dictated short hair, with the example set by the young women who worked for Charles Masterpole at his salon on the second floor above 9 Main. Second from the left is Mary Francher, and Charles' nephew John stands toward the back. John would later have his own beauty salon.

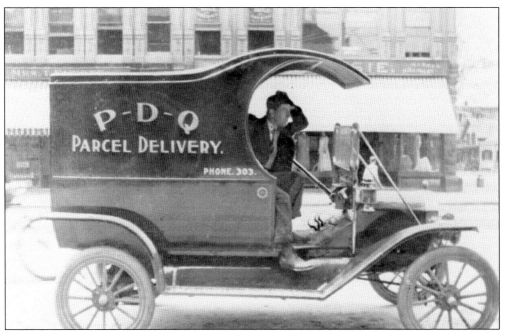

Gordon Meserve became the owner of this 1911 Ford Motel T for $700. The truck body was interchangeable with a passenger car body for pleasure driving. Meserve, as the Parcel Delivery Quick, had headquarters at Seager and Hammond's Drugstore, located on the southeast corner of Main and Clinton Avenue. Across the street is the original Wiltsie's Store. (Photograph from James Hammond Jr.)

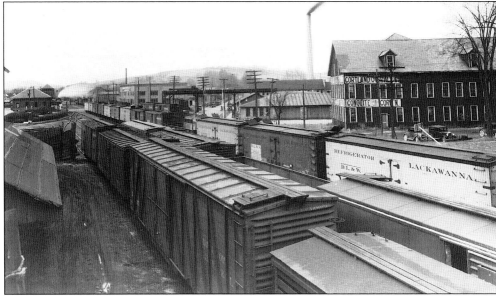

The most important method of delivering goods in the first half of the 20th century was by rail. The busiest place in the city of Cortland in the 1920s and early 1930s was the rail yard of the Delaware, Lackawanna, and Western Railroad. Looking north toward the passenger station, we see white refrigerated cars, part of a coal-trestle shed over a cattle pen on the left, and several businesses that owed their prosperity to rail service.

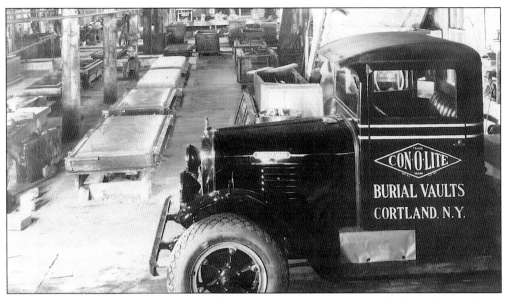

One of the city's oldest industries was the Con-O-Lite Corporation, which made use of part of the Cortland Wagon Co. factory in 1925. Based on a patent obtained by its inventor, Walter Willett, concrete for burial vaults was made waterproof. In 1945 they supplied the vault for President Roosevelt's grave at Hyde Park. The business continues as the Central New York Vault Co. on Salisbury Street, independently owned but associated with the Con-O-Lite line.

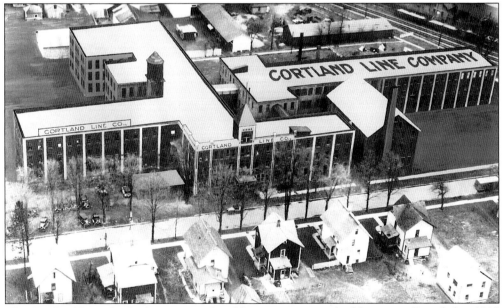

The Cortland Line Co. had its start in the old wagon company buildings, too. Founded in 1915 to manufacture fish line, during World War I it made medical sutures, and in World War II it manufactured parachute and bomb fragmentation cords. During the 1930s, business was so good that the company extended into tennis racket production. This division was later sold to Wilson Sporting Goods, while the rest of the firm was sold to a Pennsylvania firm in 1958. In 1972, ownership returned to Cortland, and in 1984, the future State Top Small Business moved to Kellogg Road.

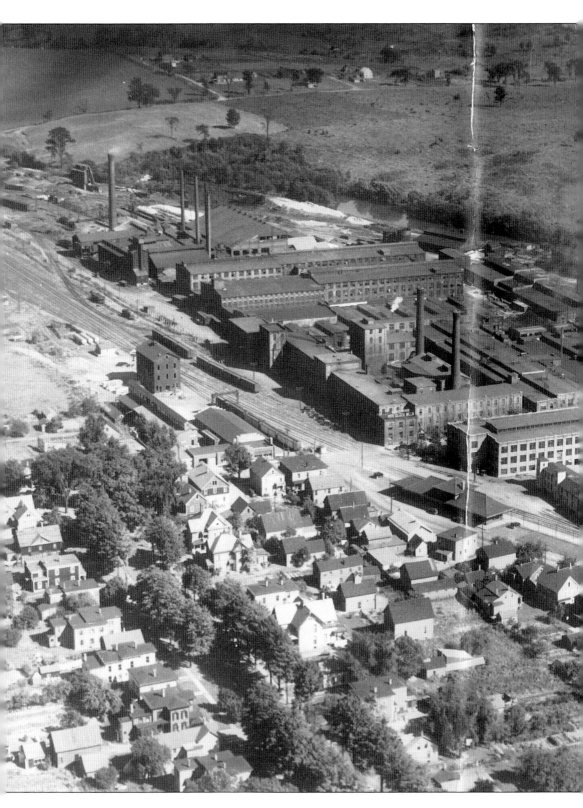

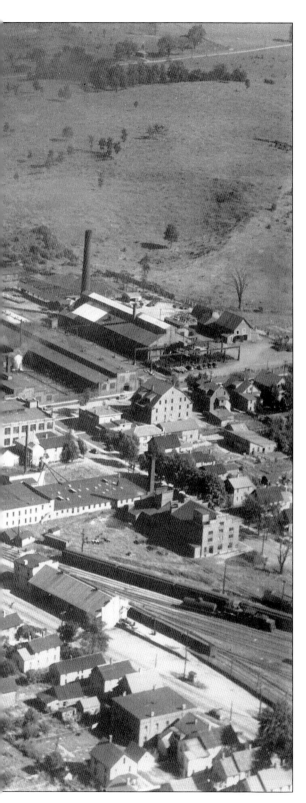

If there is any doubt that life in the city is represented by significant changes, then this photograph dispels it. Bare South Hill, between South Main and Pendleton Streets, is now covered by a complex of educational and sports facilities. The expanse of the Wickwire Brothers, Inc. mills has disappeared at the foot of the hill. Wickwire's began as a small hardware store in the Main Street shopping district. Accepting a carpet loom as payment for a debt, Chester Wickwire adapted it to weave wire into screen cloth. In 1881, the first building at the Lehigh Valley Railroad tracks site went up. By 1893 a larger drawing mill was needed, then a rod-rolling mill, then an open hearth steel plant and blooming mill. By 1906 the company extended to over 40 acres, had 1,500 employees, and was internationally recognized. A subsidiary of the Keystone Steel and Wire Co. purchased the business in 1968 at a time when modernization and foreign competition placed a heavy toll on the firm. By 1971 the mills were silent, and in 1972 they were demolished.

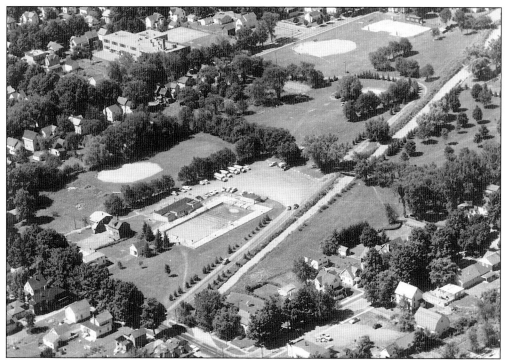

The old swimmin' holes along the Tioughnioga, like the cove off Clinton Avenue, were no longer needed. The city of Cortland would have a real swimming pool right after World War II, thanks to an impressive donation by Charles C. Wickwire Sr. It drew 40,000 persons annually in its early days. Located in the new Suggett Park, the pool inspired contributions to recreation from individuals, the Rotary club, and the Elks, Moose, Lions, and veterans groups. This photograph was taken from Homer Avenue looking toward the A.B. Parker School.

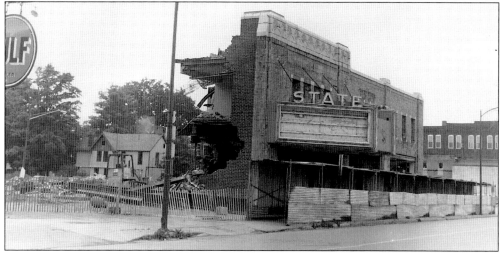

The last of the elaborate first-run theaters faced the wrecking ball in May 1973. Cortland's Shine's State, decorated in Persian style, with thick rugs leading up to the balcony and down to the restrooms, showed its first film in December 1930. A popular pastime until the 1950s, when being entertained at home by television was a novelty, management was not able to maintain an inviting interior for its shows.

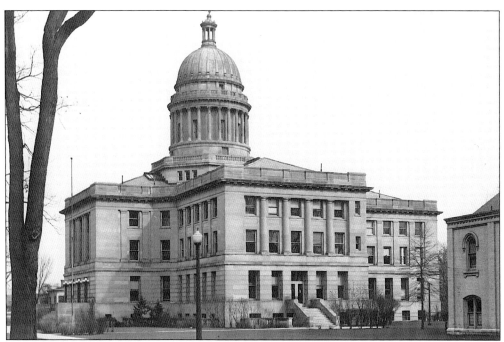

Age and fires doomed the county's second courthouse and the Normal School at approximately the same time, conveniently leaving vacant prime land nearby one another. Designed by James Riley Gordon of New York City and completed in 1924, the third courthouse was erected on the ashes of the school. Adjacent is the separate jail, and in front is a monument honoring World War I veterans. The Veterans Memorial Park is now on the lawn to the right.

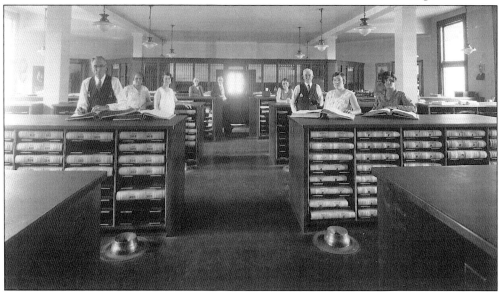

Although many years separate the county clerk's area from this 1928 view of it, its organized lay-out continues. Spittoons are out and computers are in, however. The grilled partition is gone to make room for the historic collections of deeds and mortgage ledgers. This section of the courthouse is presently named the John Kimmich Records Room. Mr. Kimmich served 18 years with distinction as county clerk.

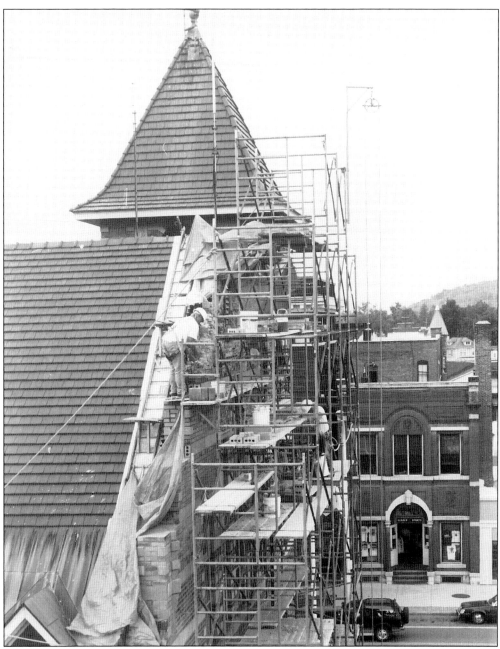

History faces-off on Cortland's Court Street. The fire station suffered through restoration in 1996 to repair weathering problems in its 1914 brick walls. The city's five volunteer companies were able to work from one location at that time. Its Syracuse architects designed the unique three-story building with its tile roof and Dutch-styled stepped gables. Across the streetstands what was built in the 1880s as the Franklin Hatch Library, founded and endowed by its namesake. From it, in 1927, came our Cortland Free Library, only doors away, where thesecond courthouse had functioned. The Hatch property was the site of the Salvation Army headquarters for many years, a warehouse, and other business interests. (Photograph by Duke Glover.)

Four

EDUCATION

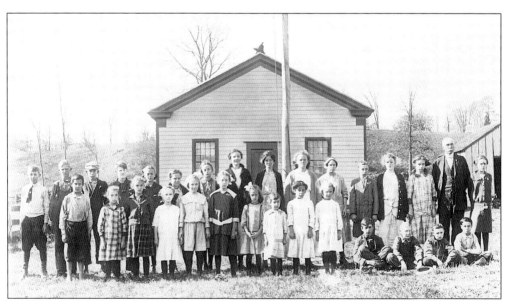

More than 180 one-room schools were scattered across the county. Common schools meant education was classless, open to all. However, it wasn't free. Most districts required at least a specific amount of firewood per student attending a stated number of days. This Cuyler scene of 1914 demonstrates the wide age-range facing the teacher. The building looks carefully tended on the exterior. The prominent flagpole appears to be a very tall, stripped sapling.

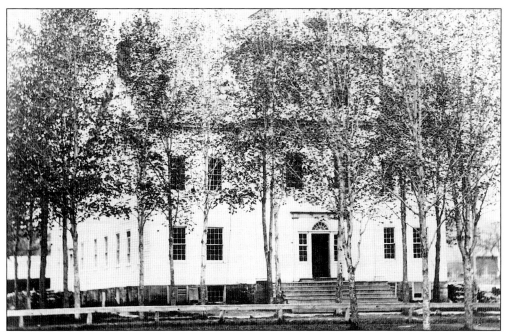

The Cortland Academy was actually in Homer. The time for higher education in this village of over 3,000 arrived in 1819. The curriculum was conventional—a classical, a scientific, and by 1836, a teacher training course. Boarding students had accommodations throughout the village, and assignments were completed in their rooms. Classrooms were for recitations.

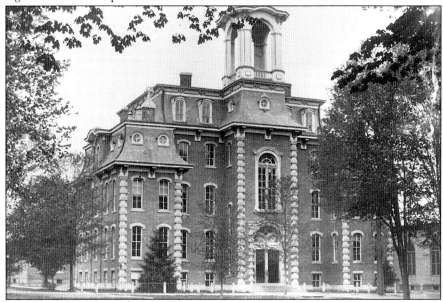

The original Cortland Academy, located on Homer Green, was constructed of wood. Fire leveled it in 1867. A three-story replacement of brick went up on the same plot, but academies began to lose state aid as high schools became a draw for the general public, and by 1873 all the academy's equipment and debts went to the Homer Academy and Union School. The brick building burned in 1893 but a nearly identical structure was soon rebuilt. That school burned in 1945 during a Cortland-Homer basketball game.

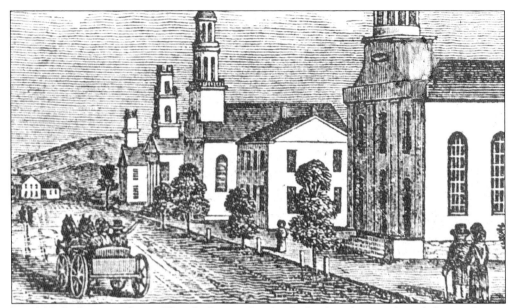

In 1846, looking north on Church Street, Cortland, the line begins: from left to right are the Universalist, Baptist, and Presbyterian churches; the two-story Cortlandville Academy; and the Methodist Episcopal church. The Young Men's Classical School was the first group in attendance in the academy, and then the Cortland Village Female Seminary (formerly on Main Street) joined them. Both had begun in 1828, and after their demise, the academy had as many as 400 co-ed students.

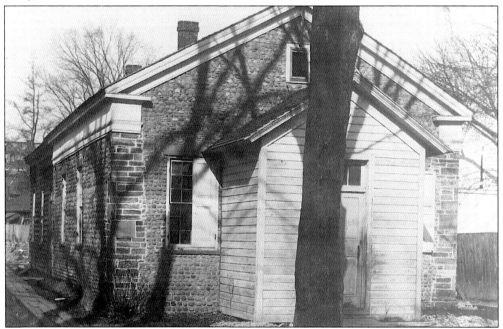

The most unusual looking school in what would become the city of Cortland was Cortlandville's No. 9, the Cobblestone School at 4 Church Street, opposite the Cobblestone Church. Its 1844 construction put the mason into debt for underestimating his costs, but it was considered by all an object of beauty. By its closure in 1893, it had become an object of derision.

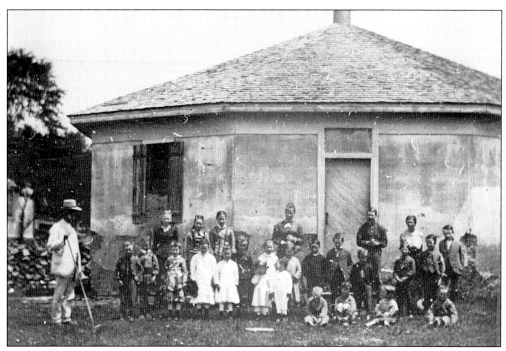

The octagon school in East Homer is remembered as being constructed of stone and cement. Dismantled in 1879, a temporary school went up by the creek until a new one was ready. A male teacher was always hired for the winter term, as the older boys' farm chores would be dormant, so they would attend then. Children were graded on the level of the reader they could use, and scribble pads were made from brown paper.

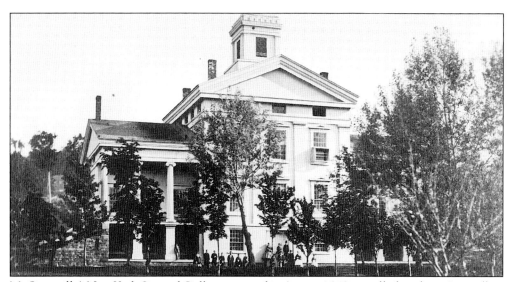

McGrawville's New York Central College, opened in August 1849, enrolled students "regardless of sex, color, or religious belief." Its financial contributors were such famous abolitionists as Gerritt Smith, Frederick Douglass, and Horace Greeley. Its 11-year existence was scarred by financial difficulties and by a smallpox epidemic in 1850. Converted to a school for local children, the building was torn down in 1885 to make room for the McGraw Union School.

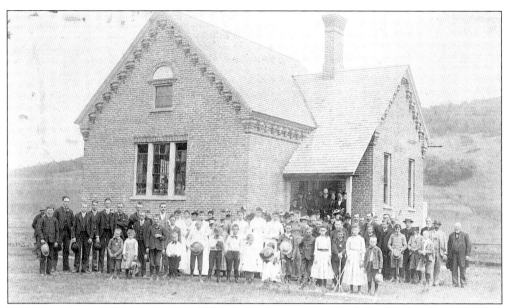

If the number of children at the 1886 dedication ceremony of the brick school was any indication, a school on this part of the East River Road was long overdue! Part of the Loring Crossing settlement (the gentleman at the far right is Mason Loring), the school suffered a fire in 1938. The eight pupils and teacher continued classes in the chapel of the nearby County Farm while rebuilding went on. The school is now part of a residence.

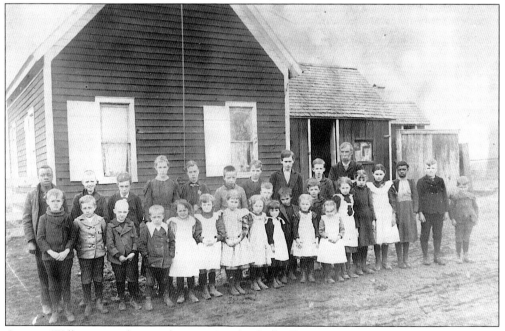

George Wilbur was the teacher at Cortlandville District No. 2 in 1898. Located on Fisher Avenue, it was nicknamed "The Sand Bank Academy," a reference to the soil's content. Sixteen of these students were Gerrards, McGuires, Hayes, and Websters. In 1946, new life was poured into the building when it was purchased by members of the Seventh Day Adventists to educate their children.

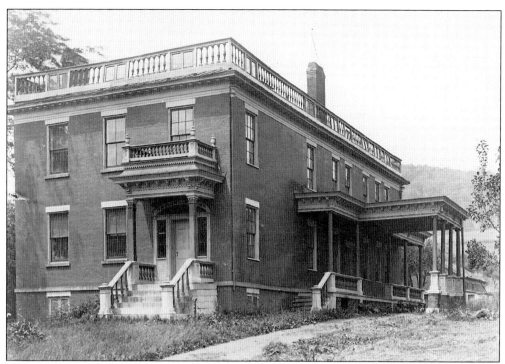

This Federal-style brick-and-stone mansion was built above the village of Truxton between 1818 and 1824 for $8,000 by Dr. John Miller. It was later the home of Dr. Judson Nelson, surgeon for the 76th NYV in the Civil War. The Miller/Nelson home was purchased and used as the high school until the centralization of the district led to the construction of a K-12 structure in 1935. That school now is a K-6, and has been named for Marion Hartnett, a teacher and principal in Truxton from 1919 to 1960.

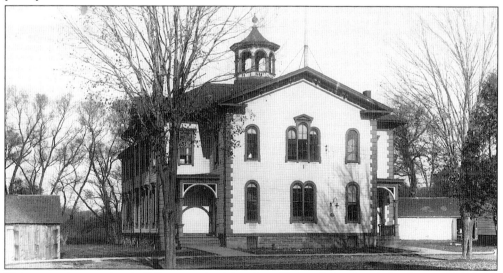

This attractive wooden building was the Marathon Union School and Academy of 1872. In the 1920s it was razed to make room for a new brick school. Marathon may be the only regional village that lost a one-room school to a creek when it eroded its bank, undermining the building and causing it to careen into the water, possibly before 1824.

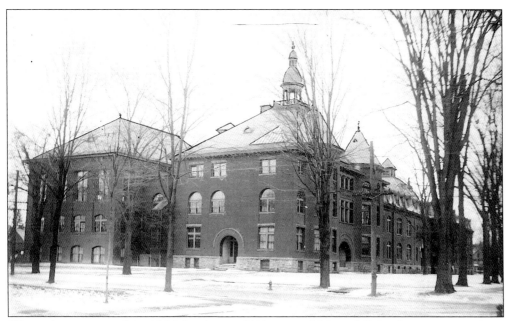

When the state acted in 1866 for the establishment of Normal Schools to train teachers, Cortland village immediately lobbied for one. On March 3, 1869, the school opened between Church and Greenbush Streets, with the condition that an academic department (high school) be maintained and village students would not be charged tuition. The building, with its twin towers, accommodated boarders in third-story dormatories.

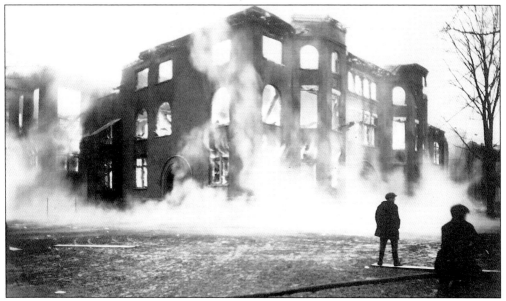

On February 27, 1919, the eve of the Normal School's 50th anniversary, a fire, believed to be caused by spontaneous combustion, roared through the brick building, which was layered inside with oak. Students and neighbors saved records and the library. Classes continued in churches, the fire station, the courthouse, the second floor of a Court Street laundry, and with split sessions with the Central School body. This lasted four years while decisions were debated at the state and local levels.

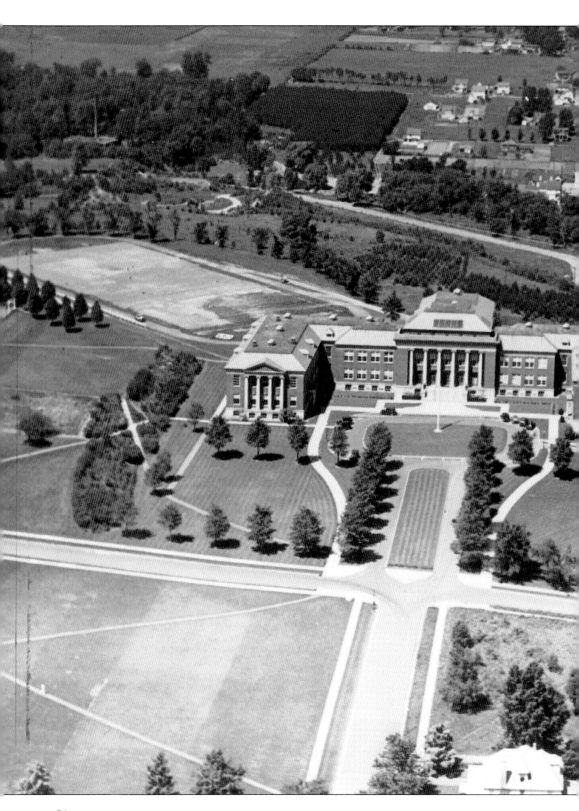

At long last, 31 acres on Court Street hill were designated for the Normal. At 1,200 feet above sea level, the million-dollar school had a magnificent view of the seven valleys of the city. Elm trees provided a promise of shade, and pine trees on a steep slope hindered erosion. An athletic field extended above and along Broadway. The first classes assembled in September 1923, but the class of 1923's graduation exercises took place in the nearly completed structure. In 1941 the school became a college. Teachers had graduated first, after two years, then three, and finally, four years. In 1948 the college was made part of the State University of New York. Once the focal point, "Old Main" is now surrounded by other campus centers. The first building now seen from the West Court Street approach is more modern in style—the Nathan Miller Administration Building.

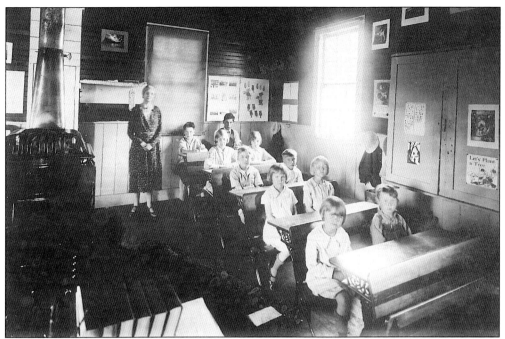

The oldest school in the town of Virgil was the West Meeting House School at the corner of Dryden and Kohne Roads. In 1930, nine school districts in the town voted to centralize. This district did not. Miss Lizzie Barnes was engaged as teacher, as seen here in 1931. Averaging ten students, after two years of independence, the vote went for centralization in the new school in the heart of Virgil. (Photograph from Frances Bays, Virgil Historian.)

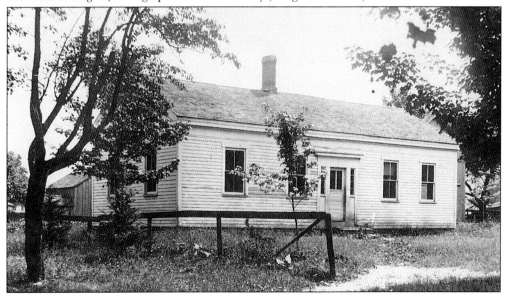

The Virgil Village School was a two-room school, and was the only one of its kind in the town of Virgil. It contained a primary and a grammar department and held classes until 1934, when state funds toward building central schools and for busing brought many changes in education. The Virgil Fire Station No. 2 now occupies the site. (Photograph from Frances Bays, Virgil Historian.)

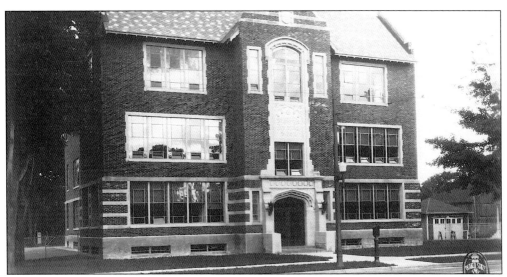

St. Mary's Parochial School in Cortland was finished to open in September 1928 with room for K-12, but only K-4 were taught. Grades were added as Franciscan Sisters from Allegany were available to teach them. The third-floor gym was replaced by a large wing with a gymnasium/auditorium and a cafeteria. The high school and junior high were closed in 1970 and the 1980s. Grades pre-K through grade six now fill the space formerly needed for the K-12 programs.

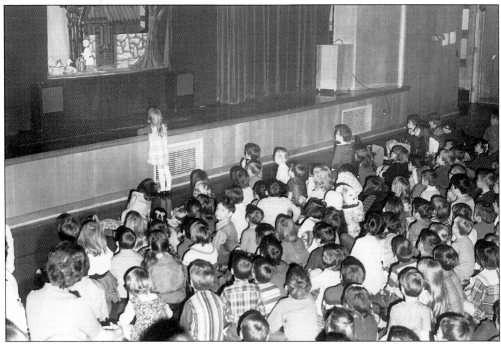

What better way to watch a puppet show than up close and personal! This 1969 show took place at the sixth annual Art Department Festival at the grade's K-12 facility in Marathon. Within a year, elementary students were moving into their own new 20-room building. Children had been housed in a variety of make-do places in this 110-square-mile district, and high school students were anxious for the renovations, which were due to be completed in the fall of 1975.

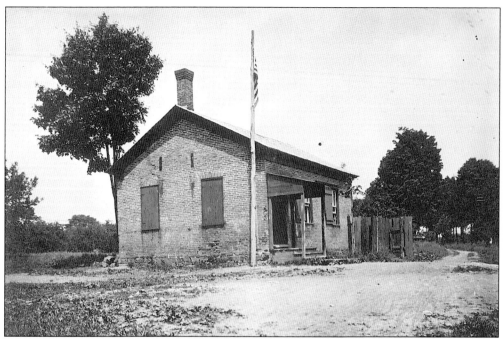

A paved Groton Avenue did not extend from the city line to the "back road" (Route 281) until 1925. From 1820 until June 1951, the little Red Brick Schoolhouse operated. Alternating between a Grange youth activities center and a designated traffic hazard by the state's department of transportation, it was to be saved and moved to the college's campus for a museum. However, instead of being restored, it was razed in 1964.

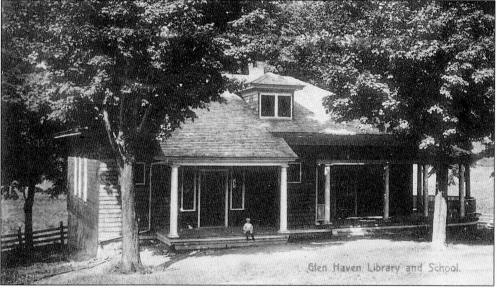

Pupils in the Glen Haven School near the southern end of Skaneateles Lake in the town of Scott, part of the Homer district for 22 years, avoided the long bus ride to Homer until 1968. That was when the one-room school with its attached small public library became the last in the county conducting classes. Ten years later the building became the center for the Glen Haven Historical Society, which opens the library on summer Saturday afternoons.

Five

HONORABLE MENTIONS

Chester F. Wickwire (1843–1910) and his wife pose in the mid-1890s in their handsome rig outside their new home on Tompkins Street, Cortland (now the 1890 House Museum). He and his brother Theodore (1851–1926) left McGrawville, operated a bicycle repair shop in Cortland, and with inventive skill and astute business sense, created a wire-and-steel manufacturing complex that produced chicken wire to parts for the atom bombs detonated by the United States during World War II.

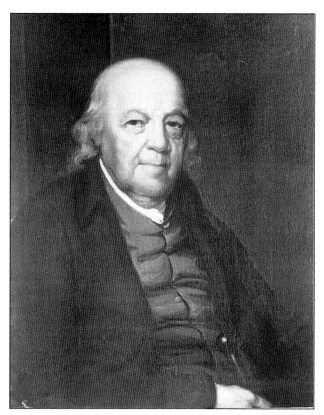

In an 1813 gazetteer, the county is listed as Cortlandt, being named in honor of the Van Cortlandt family (of Westchester County). In Goodwin's *Pioneer History of Cortland County* (1859), he states the name was for Pierre Van Cortland, "first Lt. Governor of the state, a Revolutionary War general who had extensive land holdings in the county." However, there were two Pierres. The father, shown here, served as lieutenant governor from 1777 to 1795, and ran the state. Pierre's son Phillippe had been a general, and Pierre Jr. was an officer. It was they, not their father, who had land in the county, either from speculation or the Military Tract lottery. (Photograph from Sleepy Hollow Restorations.)

Elkanah Watson (1758–1842) purchased land parcels in ten of the county's towns, and probably never saw any of them. On the one along the Tioughnioga River, south of its division, he developed a planned community, Port Watson, whose broad main street was today's River Street, Cortland. (Photo from Princeton University Art Museum.)

Herman Camp Goodwin (1813–1891) chronicled the first real history of the area in his *Pioneer History of Cortland County* (1859). To his credit, he interviewed its surviving earliest settlers or their immediate descendants, and the details he described have been the basis of much written later by other authors. A world traveler, he reported for local newspapers while living north of Homer for 40 years.

Although Andrew Dickson White (1832–1918) spent only his first seven years in Homer, his roots there dated prior to 1798 when his grandfather, Asa White, built the first gristmill and his maternal grandfather, Andrew Dickson, occupied the site of "The Hedges." Andrew's achievements include being an attaché to Russia at 22, a New York state senator, president of Cornell University at 33, and an ambassador to Germany.

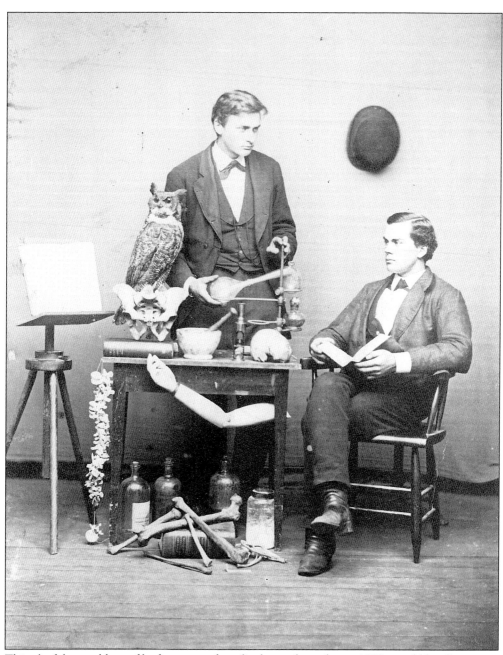

This playful assemblage of body parts and medical paraphernalia, c. 1880, would hardly suggest the beginning of a family dynasty of physicians. At this time, these men were students of Dr. H.C. Hendrick of McGrawville, who had served as a surgeon for the 157th NYV in the Civil War. Seated is Dr. Stone, while standing is Dr. Francis W. Higgins (1857–1903), who eventually came to Cortland and, in 1899, built the brick office building at 20 Court Street. Dr. Higgins died at the age of 46 at his office after shoveling snow on the very day he was to present a paper entitled "The Treatment of Heart Disease." His legacy to his adopted community was a son and two grandsons who became doctors, and a great-grandson who practices in another state.

Two state-wide figures emerged from the 1893 Cortland Normal School's Quattuor Bachelor Republican Club. Second from the right is Rowland L. Davis (1871–1954), who was a state supreme court justice from 1915 to 1941. To the right of Davis is Clayton Lusk (1872–1959). Lusk was elected to three terms in the state senate, where he led the committee to "stamp out Bolshevism" during the "Red Scare."

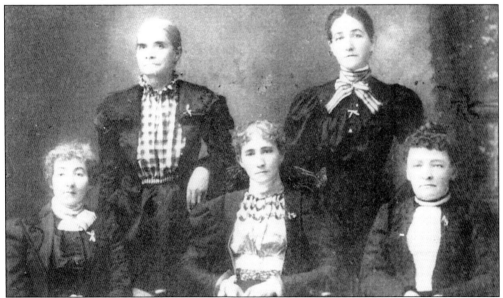

The Political Equality Club was conceived in 1898 after a lecture in Cortland by Harriet May Mills related to women suffrage. The concept was not a new one to local ladies. The first club officers, from left to right, were as follows: (front row) Miss Myra Newton, secretary; Mrs. Lucy Linderman, president; and Miss Frances Mudge, corresponding secretary; (back row) Dr. Lydia Strowbride, vice president; and Mrs. Anna Bently, vice president. Dr. Strowbridge was honored by the state in 1998 as a suffragist, with a marker placed in front of the hospital.

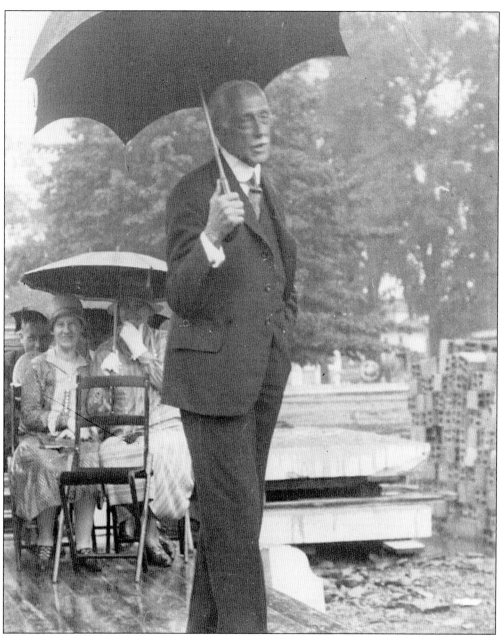

Just days old, Elmer A. Sperry (1860–1930), a motherless newborn, was brought from Cincinnatus to Cortland village to be raised at 124 Main Street by his aunt, Helen Willet. While a student at the Normal School, he wired it for lights and a bell system. He lighted the first Christmas tree in Cortland for the First Baptist's Sunday School. Among his early accomplishments was an electric auto, but he is most celebrated for the results of his 400 patents: the Gyro-Ship-Stabilizer, which prevented rocking; the Gyro Pilot, which keeps ships on course; and the Gyro Compass, which never deviates from pointing north. Modern adaptations helped the United States in its space program successes. A major contributor to funds for the new Cortland Free Library, Sperry is shown speaking at its 1927 rainy cornerstone-laying ceremony.

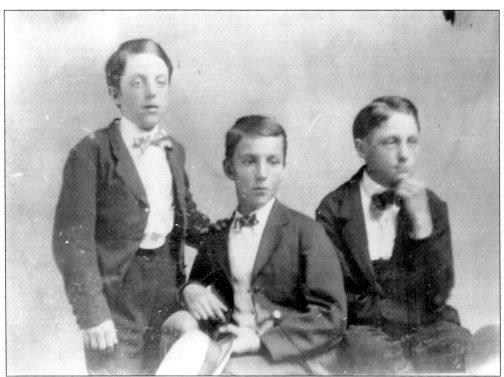

The only known boyhood picture of Elmer Sperry (right), taken from a *c.* 1875 tintype, shows him with two of his friends: on the left is Louis Blodgett Pomeroy (1861–1927), and Edward D. Blodgett is in the center. Pomeroy became a prominent bandmaster in Syracuse; Blodgett, a local newspaper man of importance; and the "thoughtful" Sperry became an inventor with few peers.

Edward D. Blodgett (1862–1926) was born on a farmland tract his great-grandfather, Nathan Blodgett, purchased from Elkanah Watson in 1805, near the branch division of the Tioughnioga River. Edward benefited his community and the Presbyterian Church in many capacities while serving as editor of the county's first daily, *The Cortland Standard*, for 34 years. His wife, Bertha, was a gifted artist and in 1932 published *Stories of Cortland County for Boys and Girls*.

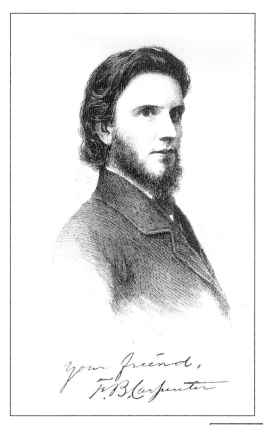

Francis Bicknell Carpenter (1830–1900) was raised on a farm on the East Little York Road. As a teen, he studied art in Syracuse, painted signs for businesses, and illustrated a book on the raising of sheep. At 20, he left for New York City to set up a studio. His painting of Lincoln reading the Emancipation Proclamation to his Cabinet dominated a stairway in the Capitol until security precautions moved it to the Senate's art gallery.

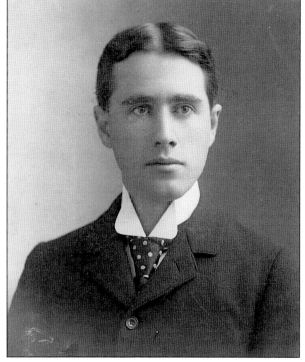

Thomas J. McEvoy (1869–1942) was a farmboy from the town of Homer. He was educated at the Cortland Normal School, and was brought back to his alma mater as principal of the Normal's intermediate department. After he left that position, he taught in the New York City system, tutored teachers preparing for licensing in that city's schools, and later became nationally known for his publishing of educational magazines and pedagogical books.

Llewellyn P. Norton (1837–1914) was born on the Scott Road. At 24 he enlisted in the 10th U.S. Calvary during the Civil War. In the Appomattox campaign, Norton and his mount leaped over a Southern breastwork, coming upon six men and a field gun. Norton's results earned him the only Congressional Medal of Honor awarded to a Cortland County resident. However, he only learned of that years after the war, when he read his name in a magazine list of winners. He received it officially in 1888.

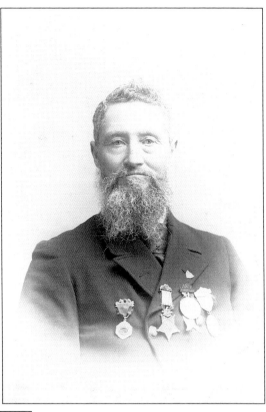

Making symphonic music popular to the masses may not have been the objective of Patrick Conway (1865–1929), but it was the result. From a stint in Ithaca, he formed a group of professionals who toured the United States and Canada. His appearances at the Cortland Traction Company parks meant thousands of fares from listeners. In 1918 he formed the Air Service of the U.S. Army Band. He not only had shared the bill, but in his lifetime he rivaled men like John Philip Sousa and Victor Herbert.

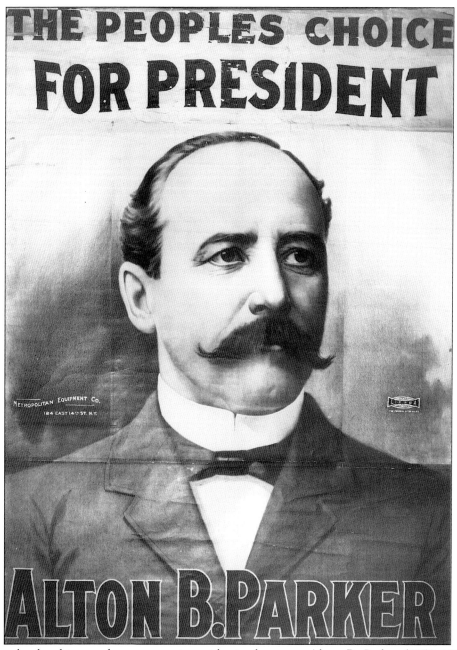

THE PEOPLES CHOICE
FOR PRESIDENT

METROPOLITAN EQUIPMENT CO.
124 EAST 14½ ST. N.Y.

ALTON B. PARKER

Quiet, hardworking, and a conservative with simple tastes, Alton B. Parker (1852–1926) was born on a farm on the road to Groton. He challenged the Republican incumbent, Theodore Roosevelt, for the presidency as a Democrat in 1904. This 10-foot-long poster is owned by the Cortland County Historical Society. Parker did not believe in campaigning and instead read his position papers to the party faithful. He had little chance of winning, as the nation was peaceful, prosperous, and satisfied, and to the voters he was an unknown quantity. His last trip home was at the laying of the Cortland Court House's cornerstone in 1922. Questions Parker raised on foreign interference, campaign finances, abuses of Presidential power, and sound money sense have not lost their relevance.

David L. Brainard (1856–1946) enlisted from Freetown in the U.S. Calvary, and lost the use of an eye from an arrow wound he received out west. Transferring to the Signal Corps, he was one of 25 original members in the Lt. A.W. Greeley Arctic expedition of 1881. The expedition was to record meteorological and magnetic observations—only six members survived. Credit for those men having survived went to Brainard, seated at the far right, who was raised to a brigadier general by Congress upon his retirement.

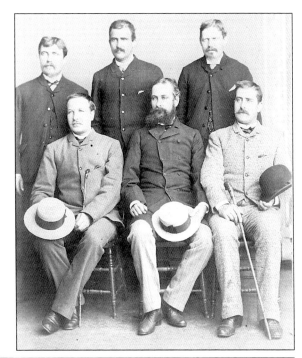

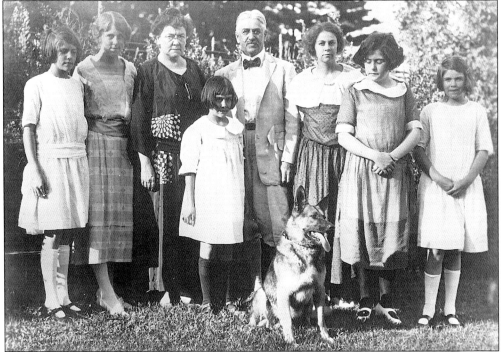

Nathan Miller (1868–1953) came from Solon, married Elizabeth Davern of Marathon, and fathered six daughters, while following a successful career as state comptroller and as a state supreme court judge. After a short hiatus from politics, he ran for governor, defeated the incumbent, Al Smith, and served one term, only to be defeated by Smith. The "economy governor" became one of the country's leading attorneys, practicing from New York City.

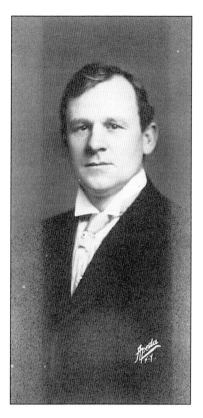

Few people have had as much of an impact on an organized sport as John J. McGraw (1873–1934) did on baseball. He spent his childhood in Truxton, a period marred by the loss of his mother and four siblings in a diphtheria epidemic. McGraw rose to be manager of the New York Giants for 30 years, winning ten pennants and three World Series. A left-handed pitcher converted to an infielder, he played with the best, and initiated the island of Cuba into the All-American game.

If ever a man were to remind one of a leprechaun, it would have been John A. McDermott (1869–1956), though few Irish sprites could equal his enthusiasm for local causes and politics. Probably the state's best known conservationist of the 1920s and '30s, he was responsible for the planting of more than 4.6 million trees. At his death, he was active in 24 different organizations.

In the 1890s, the W.N. Brockway Carriage Works in Homer was considered the largest such factory in the country owned by one person. Actually, it was a family business run for 23 years by the founder's son, George. He independently formed the Brockway Motor Truck Co. in Cortland in 1912. The production of trucks for the World War I effort helped lay the foundation for the company to be an important economic contributor to the city until the 1970s. George Brockway (1863–1953) himself made significant donations to the needy, aged, veterans, and the college.

Master of all he surveys, James M. McDonald (1881–1956) looks out over his East River Road enterprises in the early 1950s. From Missouri, he turned his retail abilities, which had caused J.C. Penney to grow, to the McDonald-Crocker farms in 1927. He built from a 1933 herd, on 1,700 acres, the nation's outstanding Guernseys. At his death, all cattle, land, and equipment were left to benefit Cornell's College of Agriculture.

He had never been in an airplane or studied aeronautics when he enlisted as a private in the Army Air Corps in 1941, but on his 25th birthday, Captain Levi Chase Jr. (1917–1994) shot down his first German Junker 88 "somewhere in North Africa." Cortland movie-goers were startled to see a segment on the Movietone News of Chase's exploits. Transferred to the Burma Theater and brought down by ground fire, he was rescued by two of his flight group. He participated in the Korean Conflict and in Vietnam, completing a total of 512 missions. His decorations were presented by five different countries and the U.N., and included the Purple Heart. We see him here in 1966 with his wife, Jean, a former teacher in Homer, as they visit the neighborhood on Chestnut Street, Cortland, of his youth. Honored by the city on several occasions, he retired as a major general and commander of the Ninth Air Force.

Six

MAKING A LIVING

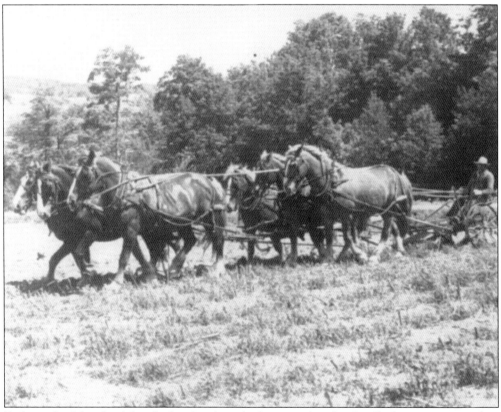

Early settlers' farmland first had to be cleared of trees and rocks. Small plots were most often plowed by man-power. As self-sufficient farms began to produce surpluses to be sold in villages or via Tioughnioga River arks, a horse might then replace the farmer on the plow. Having six broad shouldered animals to pull a simple plow through a previously tilled field was a luxury, even into the 1950s.

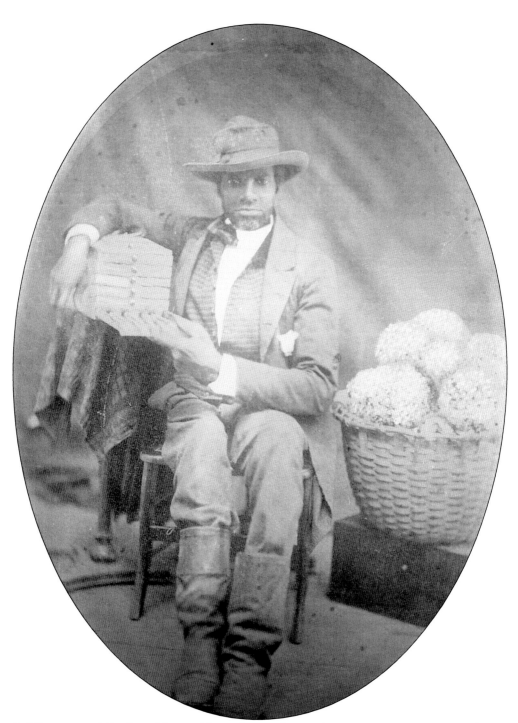

Peddling was a difficult and honorable profession. It saved customers trips to town and gave them an opportunity to purchase items not regularly found in the marketplace. Most peddlers were itinerants who did not stay long in the area, while others lived locally. They sold everything from watches to tombstones. This gentleman made and sold popcorn in Homer during the Civil War. The size of the popcorn balls probably was on a par with his popularity.

An example of Carpenter Gothic, the Winslow House once stood on the site of the present Town of Virgil Historical Building on Route 392, just off the Four Corners. In the mid-1880s it was home to a store, post office, and hairdressing shop where switches (hair-style enhancers) were made and millinery was sold. It later became a private residence before being lost in Virgil's 1926 "Great Fire." (Photograph from Frances Bays, Virgil Historian.)

The Washington House was an early inn on the northwest corner of West State Road and Washington Street, Virgil. Notice the 12 over 12 window lights and the handsome Greek Revival facade. Ed Crain, shown here, was an undertaker and owner of the place in the 1880s. Following years of deterioration, it was razed in 1958. If fire didn't destroy landmarks, neglect did. (Photograph from Frances Bays, Virgil Historian.)

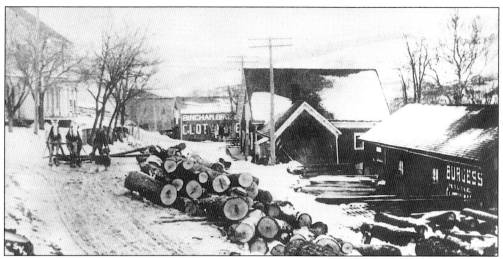

About 3 miles south of Cortland, Loren Blodgett built a dam for lumber, grist, and carding mills between 1806 and 1811. It is likely the picture is *c.* 1900, for Archie Burgess has struck, painting the gristmill to advertise his clothing store in Cortland! Before the new bridge was installed in the 1940s, the river channel was widened here at Blodgett Mills. The 100 pounds of dynamite threw mud 300 feet in the air and broke windows in the city. In 1873 the bridge cost $5,000; the newest one, in 1966, cost $167,000.

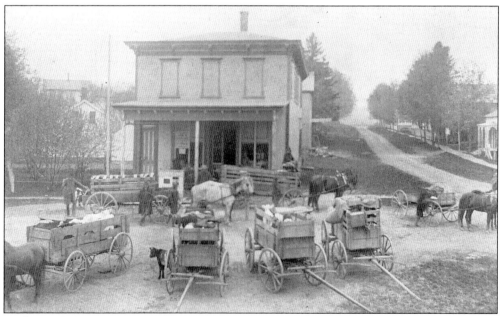

Traffic in all directions crossed in the hamlet of Virgil on the State Road and the Owego Trail. A hotel built in 1820 has, by the time this photograph was taken, become home to a grocery store with apartments in the ballroom. Nearby, at W.H. Holton's store, Mondays were calf day. Calves were brought in by J.P. Rounds and then sold to dealers, whose wagons lined the street. (Photograph from Frances Bays, Virgil Historian.)

The first dairy farmers converted their bulk milk into cheese right on their farms, but as their production increased they turned to a new business, the cheese factory. The first ever in the state was started in 1851 at Rome. Cheese factories began appearing close to the railroad stations. There seems to be no common design for them, and this one at East Homer, in the 1880s, was particularly large, with the owner's family living in the back.

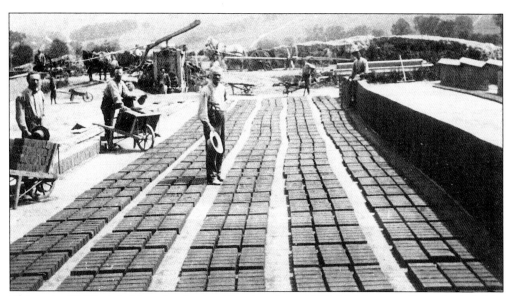

This is the Phillips's brickyard at Loring Crossing about 1890. Molds generally made six bricks at a time, as we see here, curing or drying. Woodruff and Pierce's brick works were established in 1884 on the east side of Route 281, north of the Route 41 intersection. Their first production went into Cortland's Wallace Block at the northwest corner of Main and West Court Streets. Used under wood siding, brick acted as insulation in homes.

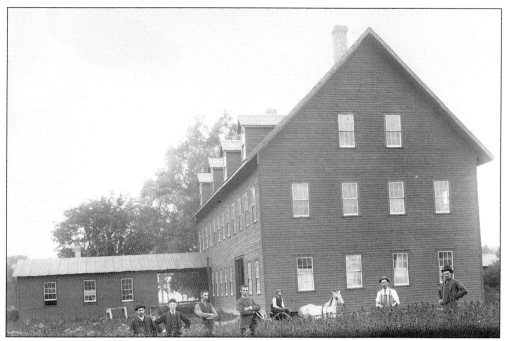

The Sturdevant, Larrabee, and Kittell Carriage Factory of the 1880s in McGraw became a paper box factory in the 1890s. The Central Paper Box Co. and the McGraw Box Co. of 1919 gave the village the nickname of "The Box City of the World." A premier box of the 1920s was a wood treasure chest containing a mirror or a music box, and is today most collectible.

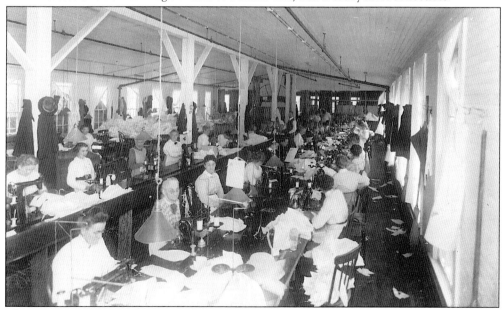

The Empire Corset Co. of McGraw produced foundation garments advertised with names such as "Never Rust," "Soroses," and "Rendezyou." To be fashionable from the 1880s into the 20th century meant a heavily corseted waistline. The Empire had a Cortland city branch at one time and employed more than 350 people. The support stays of the garments used as much as half a ton of steel daily. The company provided employment, mainly to women, from 1901 to 1950.

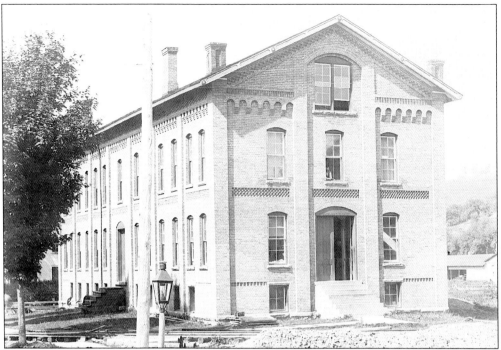

In 1873, the Warner brothers and Moses Smith made McGraw's first corset. The lack of a railroad at the time caused the Warners to move their new business to Connecticut. The McGraw Corset Co. grew out of that loss. In 1887 the Brick was built as a warehouse and shipping department and has been used by other firms in "The Corset City." A part of Higgins Supply since 1973, it manufactures aluminum and stainless steel orthopedic devices, which it sells to garment industries around the world.

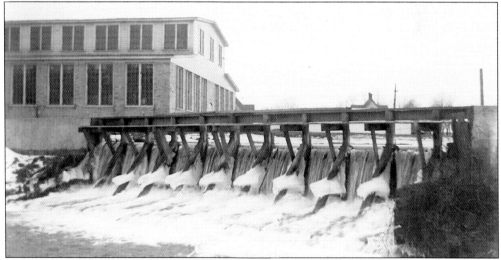

The Cooper brothers moved the business they began on the family farm in 1877 to the old paper mill on the river in 1881. Cooper Brothers made and rebuilt machines and their parts for Gooley and Edlund, Wickwire Bros., Kelsey Warm Air Furnaces, Cummings Potato Diggers, and Kennedy Gas Engines, using water-powered electricity. The plant ceased production in 1961.

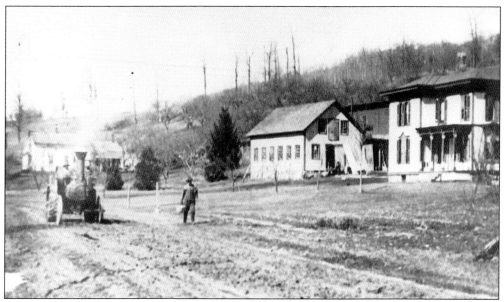

Evidence of this Scott family's prosperity at the start of the 20th century is the "modern" architecture of their home and their steam tractor. Charles Fairbank's house is to the left, the bee house and the mill in the center, and the Italianate house Charles built for his son Milton is on the right. Milton made rollers for removing the covering on salt vats in Onondaga County. The town of Scott was named for General Winfield Scott, who served from the War of 1812 to the Civil War.

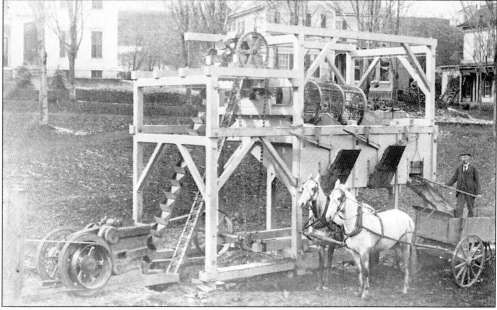

Marathon's Climax Road Machine Co. manufactured a portable machine that would crush stone for macadam roads—portable in the sense that it could be transported from job to job. Besides the stone-crusher, the firm's output included other road-building and earth-handling tools. Its market was the 48 states, Hawaii, Cuba, and Puerto Rico. The work here is on Academy Street, Marathon, c. 1900.

98

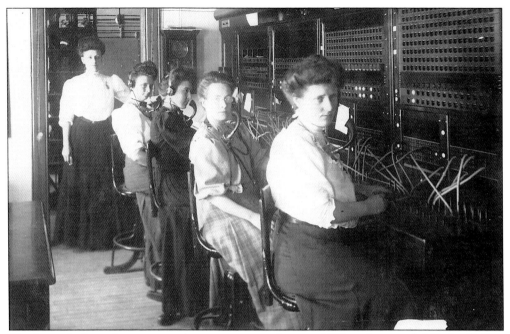

The first telephoned message in the county was in January 1878 at the crowded Taylor Hall in Cortland, which was connected to the Utica, Ithaca, and Elmira railroad station at the south end of Main Street. These are Homer's operators in 1907, wearing headsets and microphones, ready to plug in the connections. It was said that the best dressed women were the phone operators, as their pay scale exceeded those who worked in the factories.

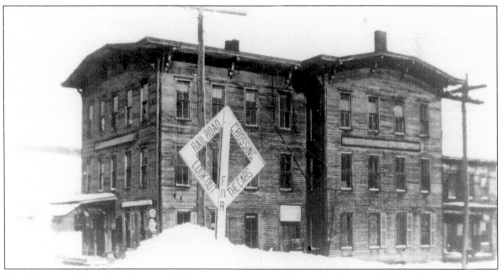

Hotels were often found in small farm communities, but to find one of these dimensions was unusual. Construction was financed by local merchants, but filling its rooms was difficult. Children were allowed to roller skate in its ballroom, and eventually the hotel in Harford became a feed store. It was the price paid for improved and faster means of transportation. (Photograph from Mary Ann Negus, Harford Historian.)

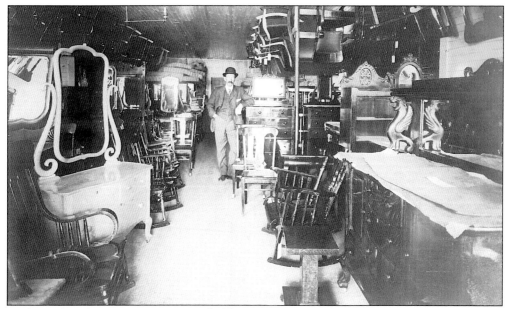

Fred Woodward's in Truxton was typical of furniture stores until about the 1920s. Room settings, as a way of enticing buyers, were first seen in this country at the Philadelphia Exposition in 1876, but space limitations in most stores usually meant stacking and hanging. Furniture stores were often the rental source for chairs for wakes and funerals, as many undertakers doubled as furniture store operators. Such was the case with Mr. Woodward.

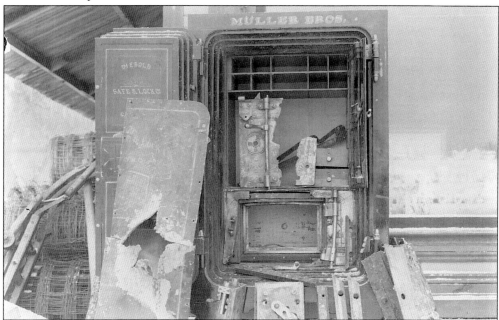

The Muller family's store in Truxton opened in the 1870s and sold hardware, lumber, and coal alongside the bank. In 1914, burglars blew up the bank's safe. The explosion blew a part out of a wall and sent a 5-pound piece flying across a creek, through a furniture store wall, and into a displayed headboard. Escaping with the safe's contents, the thieves stole a railroad handcar and pumped their way to Cuyler. Muller's business continued into the 1960s.

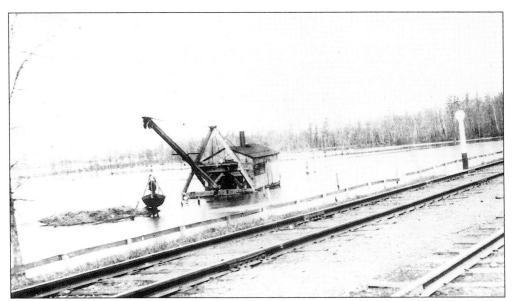

The Preble Mineral Development Co. in 1907 worked in the swamp above the Little York Lakes, cutting timber and harvesting marl. Used as fertilizer, marl is an earthy deposit consisting of clay and calcium carbonate, and is environmentally safe. Marl was also dug west of South Cortland, near Chicago. Commodore Preble, a hero of the 1803–1804 war with Tripoli, shares his name with the town.

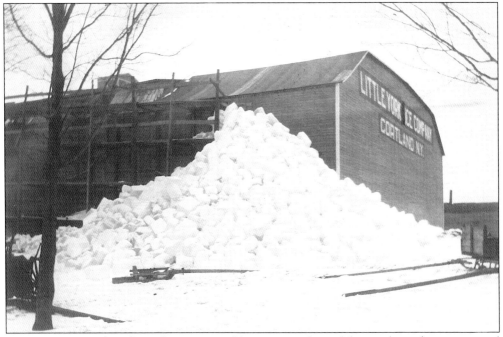

Ice was a commodity dependent upon cold winters and our lakes and ponds were natural producers into the 1940s. Saws with huge teeth cut blocks of ice, which were transported via horse-drawn sleds to icehouses on shore. Sawdust between the layers slowed melting. The DL&W contracted with the Little York Ice Co., founded in 1890 by David Van Hoesen, for tons of ice, which were loaded directly into boxcars on adjacent tracks.

101

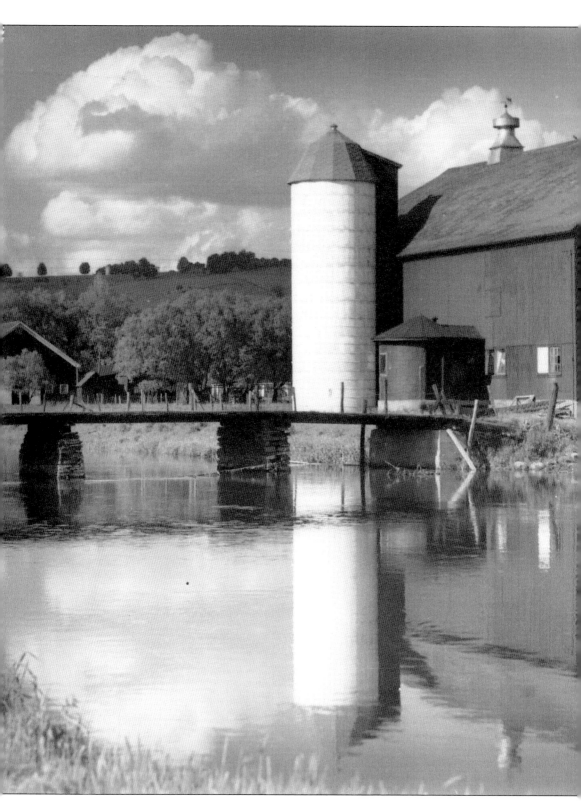

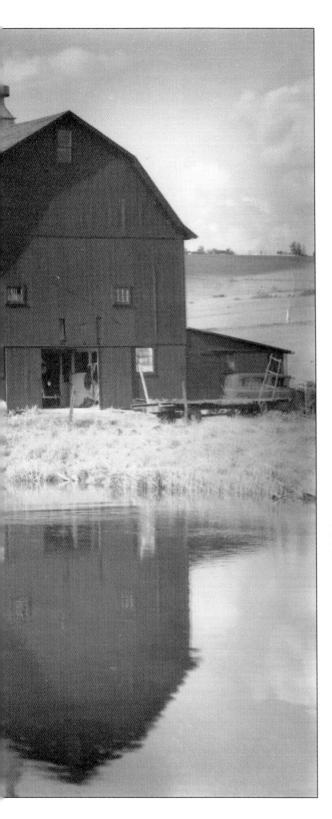

If ever there was a truly picture-postcard scene of a farm, this is it. The beautiful landscape romanticized the hard-working life on a farm. Between Cortland and Homer, this image reflected farming as it was. Now, even the long-standing silo is gone. Gambrel-roofed barns and silos no longer are required for successful dairy farming. Efficient pole barns, mechanical milkers with the results measured and posted on computers, rolled hay under white plastic tarps like giant caterpillars winding across fields, and calves sheltered in individual "condos" more truly represent this important county industry as we prepare for life in a new century.

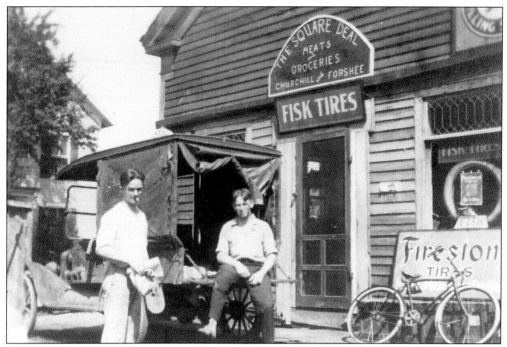

A pair of young entrepreneurs, Harold Churchill (left) and Will Forshee, offered their "Square Deal" customers in Harford an unusual combination of necessities back in 1921. It appears that they included delivery service from their Hawley Place location, once the Congregational Church's "Old Conference House." It is presently a private home. (Photograph from Mary Ann Negus, Harford Historian.)

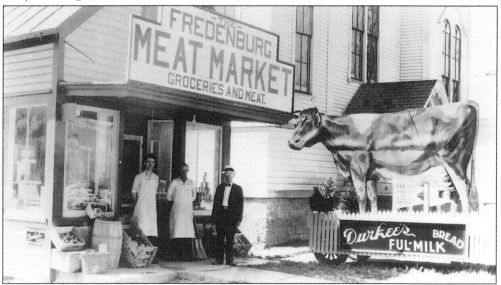

In the shadow of the Methodist church on Marathon's Main Street in the 1930s, the Fredenburg Meat Market was representative of grocery stores until after World War II. The bakery sign with a cow advertising outside a meat market was unusual. Durkee's Bakery began in Lena Durkee's kitchen in Homer in 1908. It eventually grew to cover Central New York and the Southern Tier with its goods.

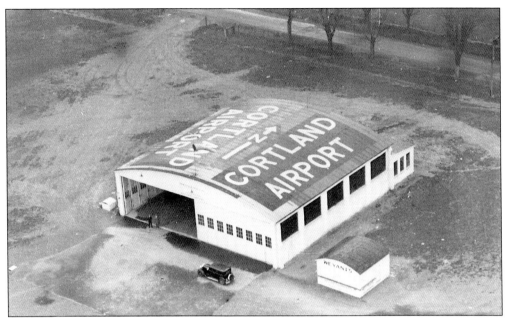

In May 1929, the Cortland Flying Club leased two properties on the Groton Road. The plans proposed a Class A airport with an 80-by-100-foot hangar with a concrete floor. Early on, barnstormers took advantage of the field and Sundays brought stunt flying, parachute drops, and races. The club leased flight operations to experienced flyers, who held classes and gave sight-seeing air tours. Weyant's Hotel on Main Street, Cortland, served 1930s "fast food" to the crowds of the special events.

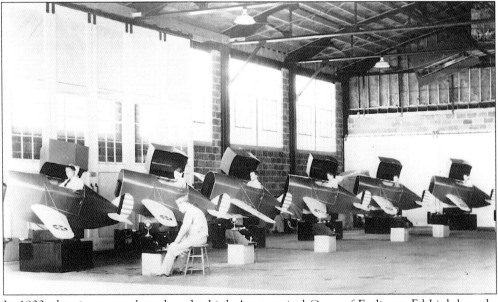

In 1933, the airport was leased to the Link Aeronautical Corp. of Endicott. Ed Link brought in his planes and supplies for making his "Pilot Maker." Link was having a great 1934 with orders and interest from the armed services for his "trainer" for "blind flying," but by the first week of December, Link was gone. A dispute with the city over $400 in rent sent Link, his 20 employees, and $400 weekly payroll to Binghamton.

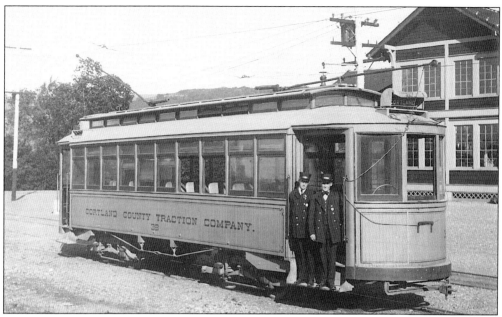

The Cortland-Homer Horse Railroad Co., established in 1882, allowed mass transportation from the depot at Railway Avenue (South Avenue) and Main Street, Cortland, to Hooker Avenue and Main Street, Homer. The Cortland County Traction Company electrified the line in 1895, and service was extended to McGraw and Preble. What had been a convenient service became a financial loss. Sold in 1928 to the Mohawk and Hudson Corp., the trolleys ceased their runs in 1931.

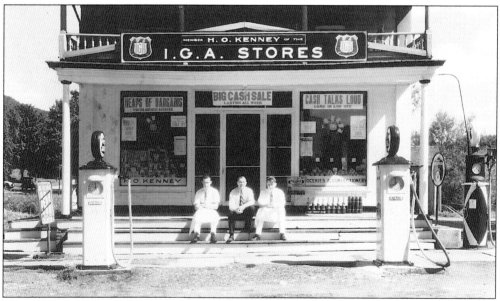

The gas pumps in Truxton are symbolic of why the trolleys ran no more in the county. Kenney's grocery store took advantage of the increasing automobile traffic on Route 13 in the 1930s. The Independent Grocers Association's (IGA) large warehouse in Cortland supplied many area stores until the supermarket chains' competition became too great, both for it and for its customers.

Large commercial spaces seldom stay empty for any length of time, as has happened with the former silk mill, opposite the viaduct between Cortland and Homer. For many years it was a showroom for the Dodge Motor Co. The Thompson Brothers Boat Co. came to Cortland from Peshtigo, Wisconsin, in 1924 and built wood outboard boats, which are still highly prized. The building has been a showplace for rugs and kitchens most recently.

Isaac "Ike" Finn (1859–1942) was considered the dean of the area's cabbies. He had transported Carrie Nation on a peaceful tour of Cortland saloons, and other dignitaries whose trains he met over many years. A cohort of David Hannum, he was portrayed as Dick Larrabee in the book *David Harum*. He was honored by receiving the first claim check and hauling the first piece of luggage from the new baggage room of the DL&W railroad station in 1902. He stands among memorabilia at the State Theater in 1934.

In the 1960s, Suburban Propane constructed a reservoir between Harford and Harford Mills to store saltwater pumped from underground caverns, where it stored propane gas. Resembling a giant football stadium, its capacity was 17 million gallons of brine. A second one has since been built to meet the demand for liquid propane and butane. Now owned by Western Energy, it has been considered a good neighbor in the town of Harford.

With forests deep with maple trees, the settlers had a ready source of funds in early spring. Sugar bushes may be modernized with plastic tubing replacing the bucket, but the resulting product is still as tasty, boiled down. The community of Marathon has capitalized on this ritual and has hosted an annual festival attended by thousands since 1971.

Seven

Leisure and Recreation

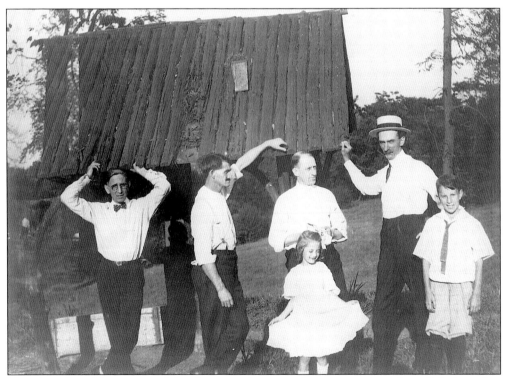

There's nothing like using one's head to provide essential support in time of need! At least that seems to be what Arthur Benjamin (in the straw hat) and his cronies are doing as they use body parts to shore-up the sagging roof. The impression comes from a cooperating photographer and friendly hi-jinks, c. 1920.

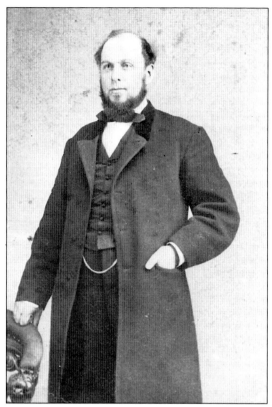

During his life, David Hannum (1823–1892) both entertained and galled Homerites with his stories, pithy sayings, and horse-trading tricks, but it was David Noyes Westcott, the son of a friend of Hannum, who immortalized him in the overwhelming best-selling novel of 1898, *David Harum*. Hannum/Harum was subsequently captured for the stage, motion pictures, and non-fiction. We see David here in the 1860s.

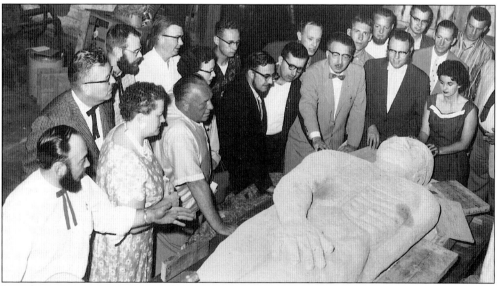

David Hannum once was quoted as saying he was the father of the Cardiff Giant, one of the world's greatest hoaxes. A granite monster "discovered" on a farm in Onondaga County gave rise to much controversy over its authenticity. While the speculation went on, the farm's owner was charging the curious 50¢ a head to view it. Hannum's investment found him competing with P.T. Barnum in showing the Giant in Metropolitan areas. The stunt's perpetrator confessed, and David lost a bundle. The 1860s figure was on display during Cortland's 1958 anniversary.

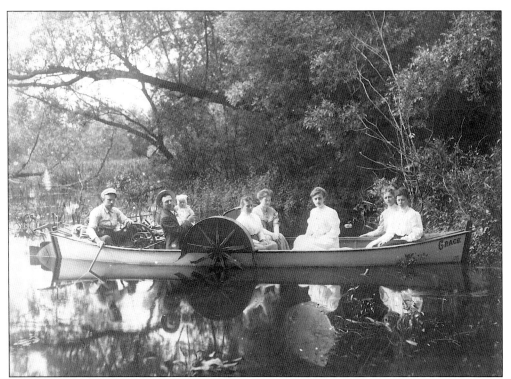

When at peace, the tree-shaded Tioughnioga was safe enough for a baby! "Grace" is not the usual plier of the river in the 1890s. C.W. Strait, in the stern, of the Strait and Jones Model Roller Mills of Homer, has his hands full with the power wheel and tiller.

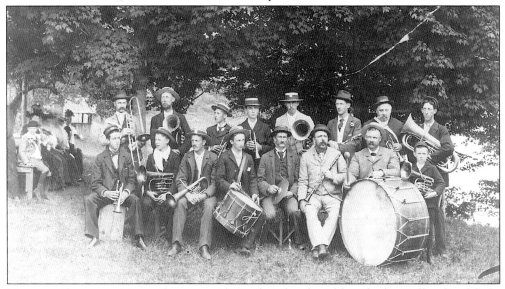

Many small communities took great pride in their bands. Although the Willett band lacks uniforms, it makes up for shortages with a wide range of ages among the players. Basically, brass and percussion instruments dominated, but here are clarinets, too. How did so many men and boys learn to play in 1895, when they lived so far from city centers? Could it be they played "by ear," as no sheet of music is in evidence?

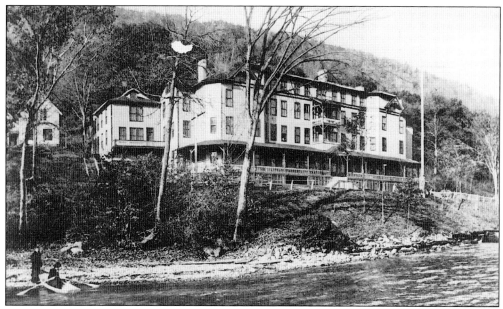

Springs from the cliff-side at the foot of Skaneateles Lake provided the hydrotherapeutic treatments for clients at the Glen Haven Sanitarium. After the original center burned, its replacement was this four-story hotel of enormous proportions, which catered to vacationers as well as health-seekers. Its 1851 Hygienic Festival's guests were temperance advocates, reformers, editors, and abolitionists. Elizabeth Cady and Amelia Bloomer slept there. In 1911, fearing pollution of its water supply, the city of Syracuse bought the 18 buildings on 160 acres. A year later, the hotel was gone.

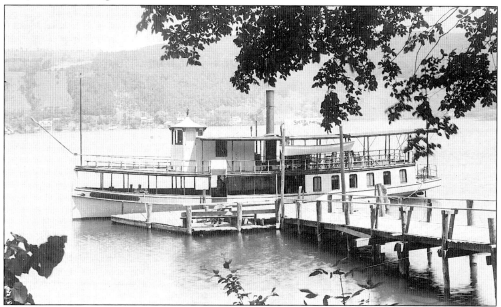

The toe of Skaneateles Lake protrudes into Cortland County and was the destination of steamboats' trips for decades. Shown in the 1890s is the *Glen Haven*, an all-weather boat with a capacity of 400, which made the 32-mile round trip from the village of Skaneateles twice a day. Passengers, groceries, and hardware items were its cargo.

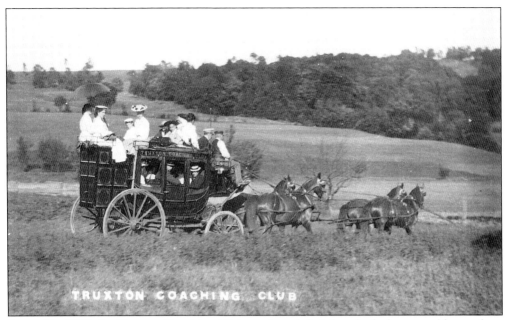

Formed in 1875, the Truxton Coaching Club purchased their hundred-plus-year-old stage from Schoharie County in 1891. Painted red with black trimmings, it could carry 20 people and the "whip" (the driver). Trips were taken as far as the Thousand Islands and as near as Sylvan Beach. Members were husbands and wives of the Nelson, Muller, and Woodward families.

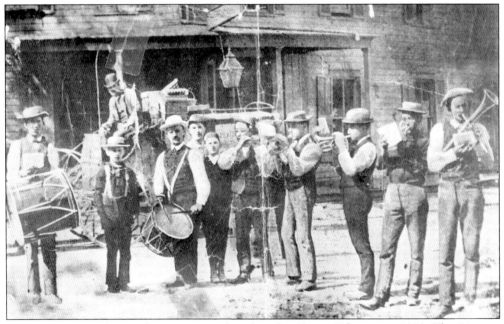

This was an 1887 battered tintype reproduced in the Elmira *Telegram* in 1910. The 14-year-old boy, second from left, is John J. McGraw. M.T. Roche, the young man on the far left, was for several years the president of the State Baseball League. The paper reported that McGraw delivered the news throughout Truxton, taking credit for McGraw's success in life because of his diligence as a carrier.

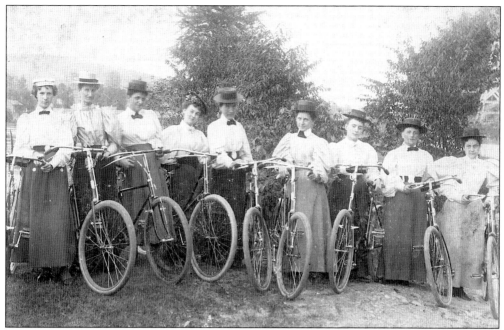

In the 1880s, roller skating was beginning to be replaced by the safety bicycle in popularity. Dropping the cross-bar favored women's long skirts. Coaster brakes and oil lamps were soon added and pneumatic tires replaced hard rubber. In 1897, the Homer and Cortland clubs united to provide a cinder riding path from Cortland to Little York (in the background, above) and another along the Scott Road.

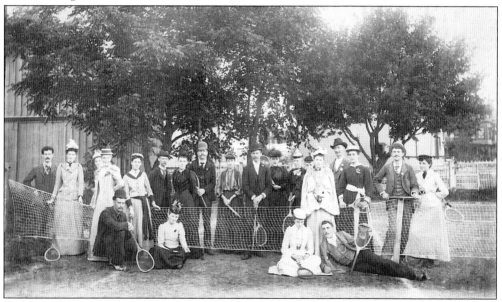

Wooden rackets strung with cat gut were manufactured in Cortland in the mid-20th century, but the shape was modified from these of the late 19th century. Tennis was at first a diversion of the wealthier families, who probably had the lawn space to indulge the sport. The net here may have provided space for two matches at a time, for what seems to us to be an over-dressed crowd of players.

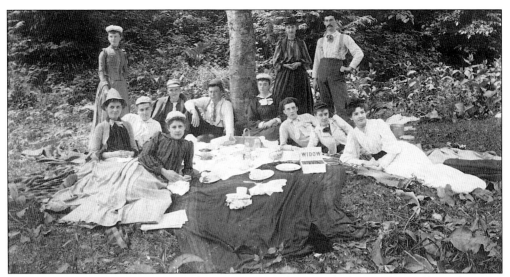

Pre-paper plates and plastic cups, these young people picnicked at Tinker Falls in the town of Cuyler about 1900. Is there a message to be perceived by the prominence of the open cigar box? Cigars were manufactured in Cortland and in Homer, but the county's climate was not conducive to growing tobacco.

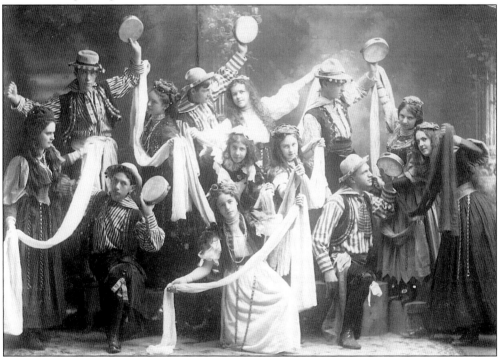

The Cortland Opera House was just west of Main Street on Groton Avenue. An imposing building with 1,000 seats, a 62-by-35-foot stage, and two-tiered boxes, it featured stars of drama, minstrel, opera, and vaudeville, plus concerts, road companies, and home-town talent extravaganzas. Alex Mahan's annual week-long music festivals attracted hundreds for the chorus alone. Augustus Dillon shakes the upper left tambourine, in a gypsy theme production in the 1890s.

Long before television and motion pictures, Cortland's Dillon brothers had become one of the country's leading theatrical families. Music, dance, and comedy were their forte. Harry and John wrote "Put Me Off at Buffalo" and "Do, Do, My Huckleberry Do," Gay Nineties hits. Will (1872–1966) invented this zippered suit for his vaudeville quick changes. "The Man of a Thousand Songs," as he was billed here and in England, penned "I Want A Girl Just Like The Girl Who Married Dear Old Dad," which still makes the sing-a-long lists.

Cortland Central High's football team played its games behind the Normal School, and later in the south end, where Beaudry Park is at this time. Looking stalwart in their turtlenecks, the team of 1902 displays protective equipment: soft leather helmets, somewhat padded pants, and wooden facial guards.

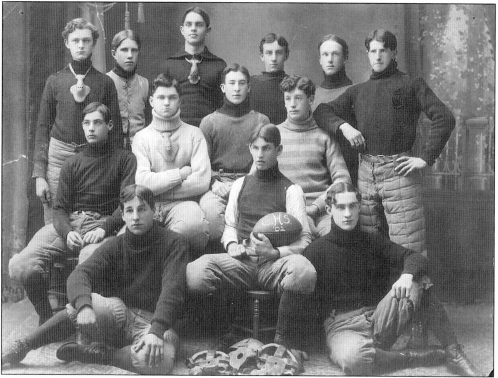

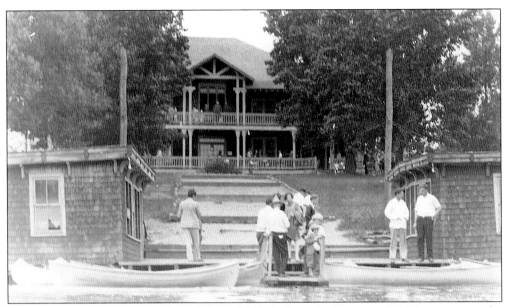

A deadly trolley accident weakened the public's faith in the Traction Co. To counteract the declining number of riders, the firm determined to abandon its park on the river and design a new one on Little York Lake, extending its line and, hopefully, its income. The park, built on some 80 to 90 acres, included a 70-by-55-foot pavilion costing $10,000. Five thousand people visited the 1906 opening, and most paid a 15¢ fare to reach it. Falling on hard times after the coming of the automobile, it was the Little York Garden Club that persisted in making it a county park.

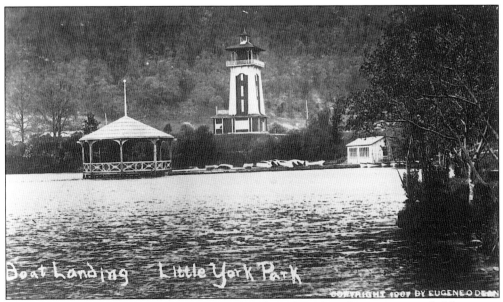

Many extra attractions dotted the grounds of Little York Park. A long pier extended from twin boathouses and ended in a gazebo. Patsy Conway's concert band played in the bandstand. Lights along the roof's edges, dances on the second floor, a restaurant, boat rentals, picnics, a water tower to climb on its interior staircase, and ice skating were four-season invitations to families.

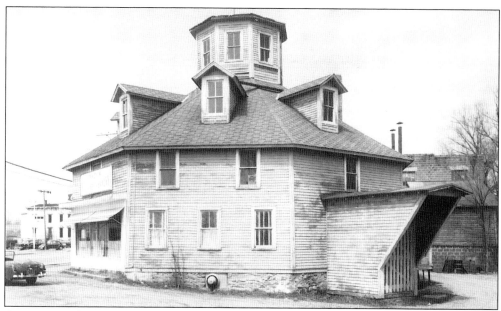

George Satterlee (1848–1928) was not native to this county, nor did he live in it long, but the symbol of his life-long endeavors stands on the main highway between Cortland and Homer. As Sig Sautelle, the owner of a circus that had traveled on barges on the Erie Canal, he built a "big-top"-shaped building, which included training rings for the animals in the off-season, and which would later become his home. Behind the building, and across the river, were small sheds that became the homes for migrant workers from the 1920s into the 1940s.

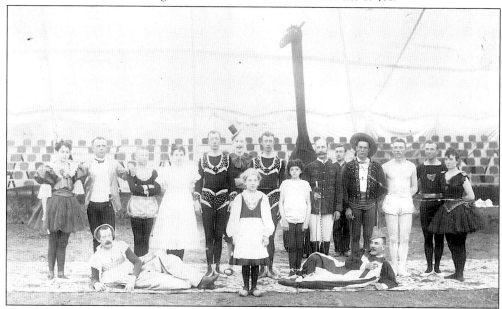

Sautelle's troupe of the 1900 season gathered under one of ten tents set up behind one of Homer's hotels. His circus was called the "Sunday School circus." Sautelle did not reuse the large tent and decorative flags year to year, but replaced them with new ones. The horses were under a veterinarian's care and were considered sleek and well-groomed. On one occasion, with even hyenas and elephants traveling by train, twenty 60-foot-long cars were filled.

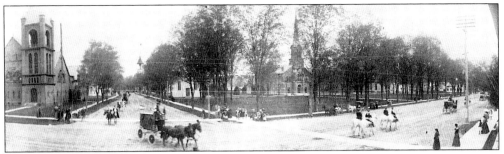

This rare photograph shows Sautelle's Circus on parade in Homer, beginning its 1901 shows. On the left corner of Main and Cayuga Streets is the Baptist church; on the right is Main Street and the Homer Green. Sautelle, a Civil War drummer boy, ventriloquist, sleight-of-hand expert, and circus legend is memorialized at the circus museum in Sarasota, Florida.

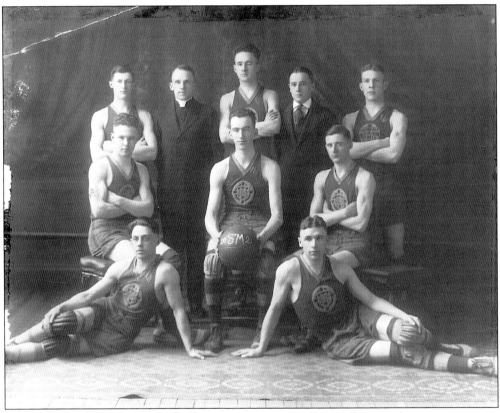

The St. Mary's Sodality basketball team, with its green and white uniforms, was a semi-professional organization that won great acclaim in the east in the teens. A game of spectacular defense against All Syracuse New Year's night, 1921, ended with a score of 6 to 2, with Art Dexter sinking the only Sodality basket. With the ball is "Deke" McEvoy, sitting between a Carr and Danny Maher. At their feet are Lyman Peck and "Dutch" McDonald. In the rear row are Elliot Corcoran, Fr. Canfield, another Carr, manager Emmet Lyons, and Dexter.

Our Cortland County Fair photographs from the early 1900s illustrate the great appeal its events had. It was not just vegetables, stock, and flowers any longer that enticed the crowds, but the Ferris wheel, merry-go-round, mechanical swings, mid-way sideshows, contests, food, acrobats, parachute jumps, and tented sales exhibits from businesses. It was a week, often in early September, when farmers showed the results of their labors, and the public spent theirs.

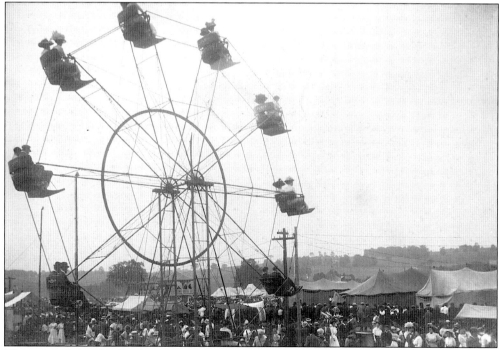

The start of the Cortland County Agricultural Society has become a bit tangled with the passage of time. Horatio Ballard recalled its beginnings in 1818 as an exhibit followed by a parade. Other sources give September 1839 as the first fair, held at Cortland village's Eagle Tavern and organized by Paris Barber. Eventually, land on the Plank Road was acquired and a design was prepared by Barber.

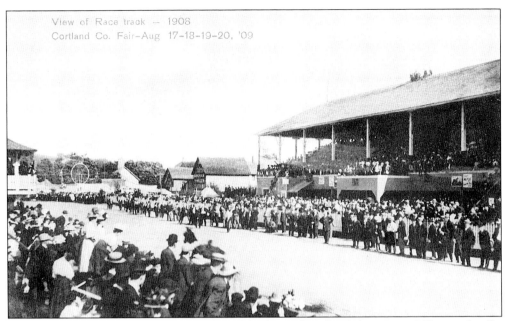

The Fair Grounds racetrack and grandstand had a multitude of distractions! Foot and sulky races, rodeos, Lucky Teeter and his daredevil auto drivers, and concerts and vaudeville acts brought in great numbers of spectators. A famed racehorse that dropped dead on the track is believed to have been buried under it.

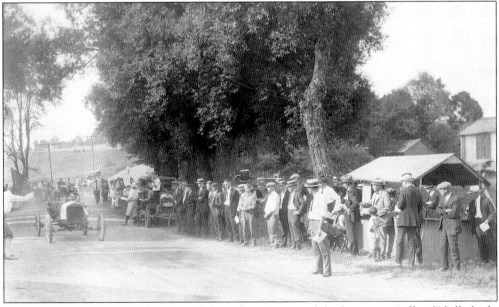

What better way to prove the invincibility of one's automobile than at an "official" hill climb, especially when steep hills abounded throughout the county? Captured here is a climb of 1924. An earlier challenge was on Pendleton Street, which was conquered by C.L. Kinney with two passengers aboard in 1900, the year the city's first car arrived—an Oldsmobile. Highland Road offered climbing opportunities for motorcycles in the 1930s and early 1940s.

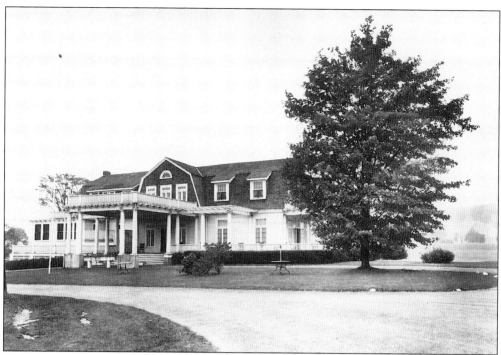

Nathan Miller and Theodore Wickwire called a meeting of those in support of having a Cortland Country Club. The club teed off in June 1914 with a golf professional hired for $60 a month, 15¢ an hour caddy fees established, and guests being charged 50¢ for greens' fees. The year 1919 was marked by the sale of the club's livestock, which had come with the farmland on the "back road." In 1946 the golf course was expanded to 18 holes, the 19th being part of the clubhouse from 1937.

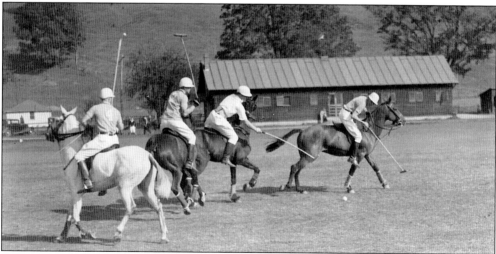

Polo was introduced to Cortland at a Memorial Day exhibition at the Fair Grounds, and a club was arranged by individuals who owned riding horses. Early members included Robert Foley, Bob Ames, C.C. Wickwire Sr. and Jr., B.T. Jones, Dr. Dan Reilly, and Bob Clements. In March 1930, the club purchased 18 acres a mile north of Homer. Stables and a bridle path were added, but expenses in maintaining the field saw its demise in the 1950s.

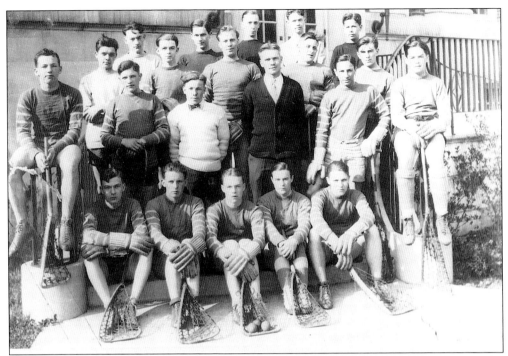

Cortland Central School added lacrosse to its sports at the end of the 1920s. George Latimer (in the center of the front row) was inducted into the National Lacrosse Hall of Fame in 1973 as a three-time All-American player at Rutgers University from 1930 to 1932. Familiar names on the team are "Dasher" Cox (on the right rail), Dr. Alex Gilfoyle (in the second row, third from the left), Bill Morgan (fourth in third row), and John Beaudry (far right in the back row).

Young women in hats and gloves danced with their dates on the 3,000-square-foot floor at the airport in the 1930s. The hangar's housing of aircraft at this time was sometimes interrupted by a change in ownership or the lease, although dancing was held in conjunction with the 1931 port's seasonal opening. Orchestras were hired and played from a raised platform. The floor also supported a roller skating enterprise in the late 1930s.

Little York is more than a lake. A settlement was there, perhaps as early as 1806. At the lake's south end, dams and flumes directed water to operate grist, wool carding, and peg mills—one of four stories that ran around the clock. Across the road was the most popular swimming hole of the 1920s through the 1940s. Besides farms, Little York (believed to be named after a successful War of 1812 encounter by American forces in Canada) had a school, rail station, and a knife factory.

MORNING STAR MANOR

Beginning in the 1870s, Little York Lake became the most popular summer place between Binghamton and Syracuse. The DL&W ran as many as three sections a day of young people ready to picnic, dance, or ride a steamer (they carried 25 people). Morning Star transformed the Raymond House resort into a summer camp during the 1920s and '30s.

Is he recognizable without his trombone? A musician's musician, Newell "Spiegle" Willcox progressed from the Cortland YMCA band to international acclaim. Thousands in central New York have danced to his orchestras or tapped their feet at his concerts. "Spiegle" performed with jazz greats Paul Whiteman and Bix Beiderbecke. He keeps his lip in shape with the Old Timers Band in between his North American and European gigs.

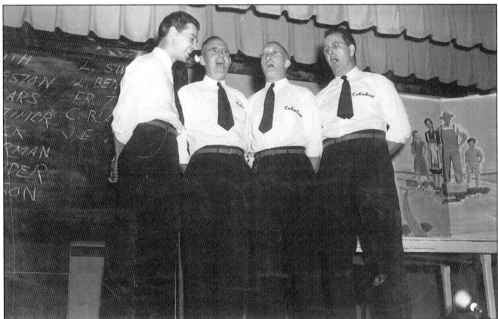

"Cobakco," the Cortland Baking Company, used sports and music to promote its bread, rolls, and donuts. The Cobakco Trio performed over WFBL radio out of Syracuse and at church choir competitions. The Cobakco Four are shown here singing at the Virgil School in 1944. They had great appeal in an area that supported a number of choral groups. These men are Messers Dutcher, Keator, Luther, and Seyerle.

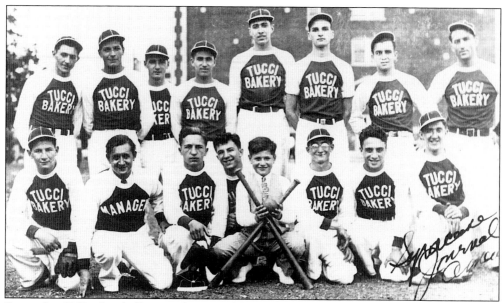

Since the 1870s, baseball teams have proliferated in number, sponsored by businesses and organizations. Tucci's Bakery, once at the corner of Elm and East Garfield Streets in the city, posed c. 1940 next to Pomeroy School. Their mascot, Arnald Gabriel, was the conductor of the Air Force Band, Symphony Orchestra, and The Singing Sargeants from 1964 to 1985, directing them in all 50 states and in 46 countries.

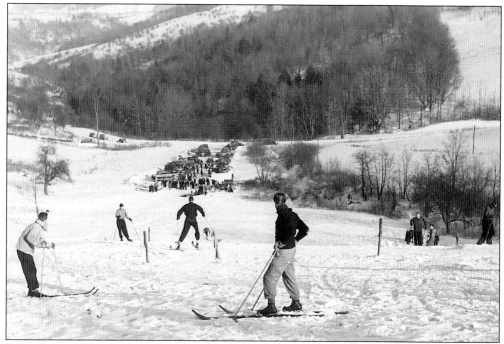

Skiing had a limited popularity, in spite of all our hills, until the Cortland Ski Club developed Snow Crest in 1947, 4 miles south of the city on Page Green Road. With its rope tow and converted chicken-house clubhouse, the East Virgil slope entertained skiers and spectators into the late 1950s, aided by the dedication of the club's volunteers.

Whether it's Trout Brook or Grout Brook, or any other county creek, fishing is a lure. Some of the world's premiere fish line is marketed with the Cortland brand. Jim Hammond Sr., in 1950, wades the Tioughnioga at Bell's Mill in Truxton with his fly rod and his pipe.

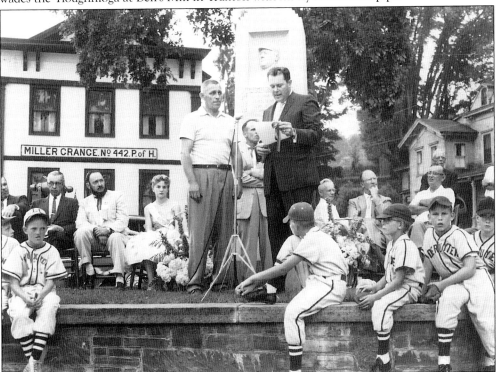

In 1934, the New York Giants baseball team won an 8-1 game over the Truxton Giants at John McGraw Field, an event witnessed by 7,600 fans. This memorable day was to raise funds for the memorial dedicated to the legendary McGraw in 1942 in the center of his birthplace. During the county's 150th anniversary, a program took place, with Little Leaguers attending, at the only monument in the country with a baseball at its top.

Skiing's following depended as much on transportation as the weather. With the advent of multiple-car families, tour buses, and improved roads, Greek Peak, a facility with trails whose titles related to the other classical central New York names, opened in the town of Virgil in 1958. Governor Harriman and a teenaged Debbie Bennett cut the ribbon and made a run down the mountain. Song Mountain, Intermont, and Labrador also became popular ski attractions in the county.

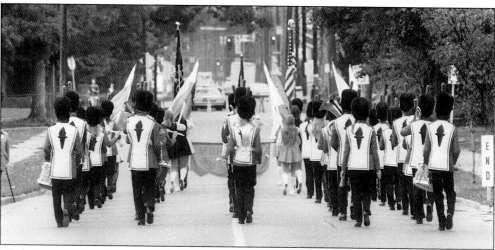

We bring to a close this pictorial scanning of the history of Cortland County by following the Marathon High School band as it parades past the judges in a 1977 competition. (Photograph courtesy of *Binghamton Evening Press*.)